Design
Elements:

Color Fundamentals

© 2012 Rockport Publishers

First published in the United States of America in 2012 by
Rockport Publishers, a member of Quayside Publishing Group

100 Cummings Center
Suite 406-L
Beverly, Massachusetts 01915-6101
Telephone: (978) 282-9590
Fax: (978) 283-2742

www.rockpub.com
www.rockpaperink.com

10 9 8 7 6 5 4 3 2 1

ISBN: 978-1-59253-719-8

Digital edition published in 2012
ISBN: 978-1-61058-1899

Library of Congress Cataloging-in-Publication Data available

Design: Aaris Sherin
Cover Design: Oska Ho

Printed in China

A Graphic Style Manual for
Understanding How Color Affects Design

Design
Elements:

Color Fundamentals

Aaris Sherin ● ●

ROCKPORT

Rockport Publishers
100 Cummings Center, Suite 406L
Beverly, MA 01915

rockpub.com • rockpaperink.com

Contents

"Color problems are an excellent vehicle for developing a discriminating eye for color choice, composition and a greater understanding of what constitutes visual sensitivity."

— Rob Roy Kelly

Introduction:
Color in Design

Why Color Matters

Color is one of the most powerful tools a designer has to communicate a client's message. It can symbolize an idea, can invoke meaning, and has cultural relevancy. Successful color relationships can determine whether people buy a product or use a client's services. Color can aid in wayfinding, it can give structure to projects with multiple components, and it can show emphasis and convey mood. Whether it is suggesting space or showing movement and rhythm, color always has a story to tell.

As much as color can help to catch and hold a viewer's attention, it can also present myriad challenges for the designer. The subjective nature of color may cause a designer to shy away from using bold combinations or from taking risks with tone and value. Preferences for certain colors sometimes get in the way during the approval process with a client. Cultural associations can lead some viewers to misinterpret information, and the technical difficulty of representing a color correctly on screen, in print, and on other media can be daunting. Fortunately, as difficult as it may seem to choose the right hues for a project, there are numerous examples of engaging graphic design that are made possible by successful color relationships.

Learning which colors work well together and how to create successful tonal relationships will save time and money. But more importantly, color can help designers elicit the correct response from an audience and produce striking graphic design.

Chapter 1
Communicating with Color

What Is Color?

In a world where first impressions are formed in as little as one-twentieth of a second, color can help the designer catch a viewer's attention and communicate information in a busy visual environment. Color can also help the viewer quickly make the correct association or have the right reaction to a product brand or service. Color acts as an exclamation point, as a way to achieve compositional balance, and as a tool to suggest and convey meaning.

Color seems concrete in our physical environment, but it is actually created by varying wavelengths of light that, when reflected off a surface, are interpreted as color. We see color because rods and cones, which are part of our optical system, are able to tell the difference between these rays and their frequency. The specific color that is perceived by a viewer is determined by the degree to which a surface is able to reflect light and produce rays of different lengths. Reds have the longest wavelengths and violets have the shortest. White contains all color and black is produced by the absence of color or a surface where no visible light can be reflected.

▲ In a high-traffic area, it is color that calls attention to this sign and makes it more noticable.

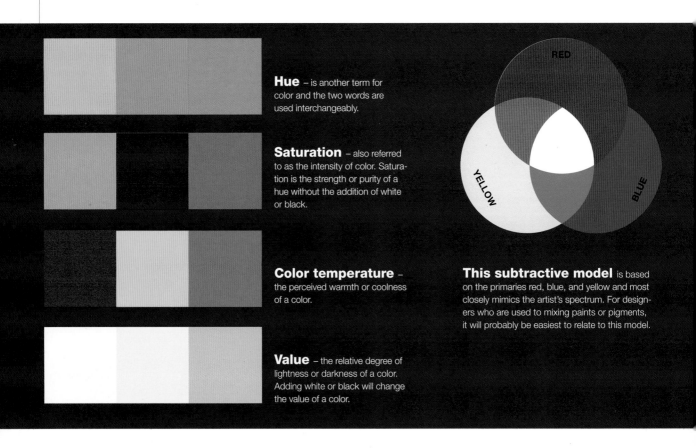

Hue – is another term for color and the two words are used interchangeably.

Saturation – also referred to as the intensity of color. Saturation is the strength or purity of a hue without the addition of white or black.

Color temperature – the perceived warmth or coolness of a color.

Value – the relative degree of lightness or darkness of a color. Adding white or black will change the value of a color.

This subtractive model is based on the primaries red, blue, and yellow and most closely mimics the artist's spectrum. For designers who are used to mixing paints or pigments, it will probably be easiest to relate to this model.

One often thinks of applying color to a large area in a design, but sometimes less is more. In this composition, the image is the primary carrier of color.
Design: Bob Wilkinson, Abuja, Nigeria

The hues that can be distinguished by the human eye are referred to as "the visible spectrum" and are composed of a fairly limited range of colors, including red, orange, yellow, green, blue, blue violet, and violet. In their absolute form, the visible spectrum can be further limited to colors, which are most different from each other. These hues are referred to as primary colors and include red, blue, and yellow. A small change in the frequency of a primary color will cause the eye to perceive a new hue. The human eye is able to discern about 10 million colors, all of which are combinations of the basic primaries. Since light creates color, it also affects how we perceive hues and their value and intensity. Strong light intensifies color and low light dulls it. In extremely low light conditions, some colors may barely be visible and it can be difficult to distinguish between hues of similar value.

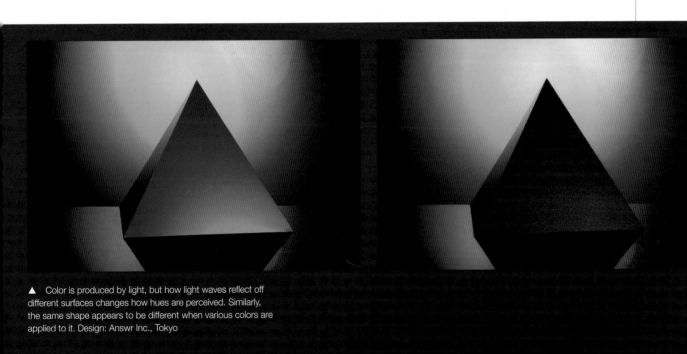

Color is produced by light, but how light waves reflect off different surfaces changes how hues are perceived. Similarly, the same shape appears to be different when various colors are applied to it. Design: Answr Inc., Tokyo

Color Temperature

The temperature of color refers to a measurement or, the power, in degrees Kelvin that indicates the specific hue of light present, but in most situations, temperature is understood as the difference between warm and cool hues. How the human eye recognizes color temperature will vary depending on the light source. Lower color temperature implies warmer light (yellow and/or red) and higher color temperature usually suggests cooler tones (green and/or blue).

There are several implications for design when considering color temperature. The temperature of the hues within a layout can affect an entire composition. Also, when creating design work on a computer, the temperature of the monitor can change how colors are perceived on screen. Calibration utilities that are built into operating systems (as in the case of Apple products) and special software can measure a monitor's color temperature and adjust it so that what is seen on screen matches the intended output more closely. Calibration is particularly important when working with digital photography and digital prepress.

▲ This highly saturated palette manages to include numerous colors and shapes without appearing to be too busy.
Design: Diego Giovanni Bermúdez Aguirre, Valle, Colombia

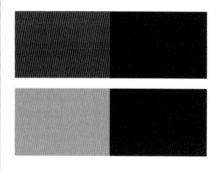

Saturation (Also Referred to as Chroma)

A more saturated hue is stronger, more vivid, and/or brighter. Duller colors are referred to as being desaturated.

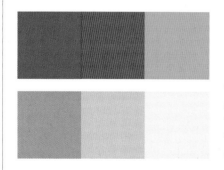

Whether a color appears to be saturated will be somewhat dependent on what colors it is next to. Understanding which hues appear to be vivid will allow the designer to use intense colors to achieve greater visual impact.

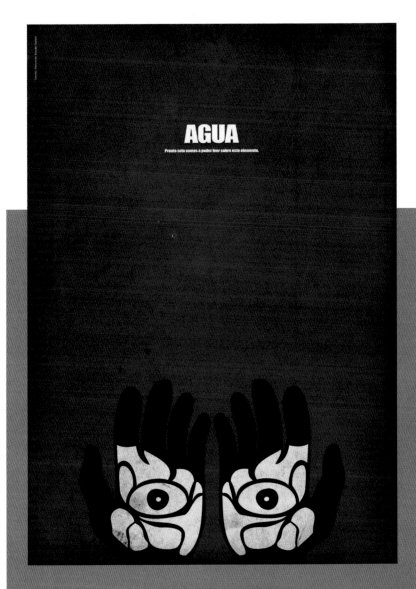

▲ One might think that a poster about water should have a cool temperature, but this composition stands out because it uses blue as an accent on a warm red background. Design: Fernando Revollo, Cochabamba, Bolivia

▲ ▶ Highly saturated color palettes are effective at getting a viewer's attention, but in this case, the designer chose to use slightly duller colors on a bright white background. The light background contrasts with the shapes and makes them more noticeable. Design: Rubén Moreno, Caracas, Venezuela

▲ Bright yellow accented by orange is combined with a red violet hue to give this poster an intensity that is characteristic of bright, warm colors. Design: Antonio Perez Gonzalez Ñiko, Xalapa, Mexico

Color and Value

Value is the relative lightness or darkness of a color and is an important tool to add emphasis and establish visual hierarchy within a composition. On its own, color is stronger than value. For instance, a gray tone will blend into a series of similarly colored shapes, but adding a color to one of those shapes will make it stand out. The effect of value on a composition is relative and is determined by the lightness or darkness of all the other elements within a layout. The greater the difference in value among compositional elements, and against the background, the more contrast there will appear to be. Therefore, value is one of the best ways to achieve contrast in design.

Notice how the same color gray appears to be different depending on whether it is next to a darker or lighter tone and if it is in the foreground or background.

Altering value is an easy way to indicate heirarchy and relative importance. By changing the value of one circle, more emphasis is placed on the composition on the left.

Value can be an excellent tool for showing relative importance. Two shapes of equal size and value will appear to have equal importance. However, if the value of one of those shapes is altered, the darker or brighter value will stand out and seem to have more significance.

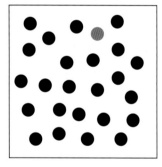

Value can also be used to show movement or to make a viewer's eye travel around a composition. Making some objects within a composition darker and others lighter will cause a viewer to first look at what stands out most and then at what stands out least.

◀ Changing the value of some elements in a design is an excellent way to make certain parts of a composition stand out. These two value studies are an example of how different the same piece can seem when varying degrees of gray are applied to elements within the composition. Design: Lindsey Burris, Rochester, New York (courtesy of Bruce Ian Meader)

Value and intensity can be broken down into seven visible steps. These are the maximum variations that will be discernable to the human eye.

Altering the value and intensity of hues used within a composition is one of the ways that a designer can achieve visual harmony within a composition. Since a viewer's perception of color is always relative, one can make colors "seem" brighter by putting them next to duller tones.

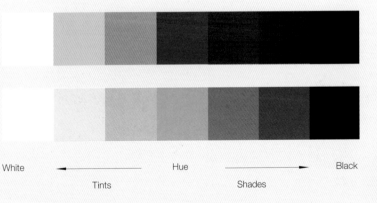

White ← Tints Hue Shades → Black

Theory in Practice

Scientists and artists have studied the effects of color and the relationships that different colors have to each other for centuries. A variety of theories, rules, and ideas have developed to explain how color is perceived and how this information can be applied to art, science, and design. While it is not necessary for designers to be familiar with every one of these principles, understanding the basic relationships between colors and combinations of hues can help a designer make better and faster decisions. By employing known principles and rules, it is easier to create work that is visually pleasing and better at conveying a client's message.

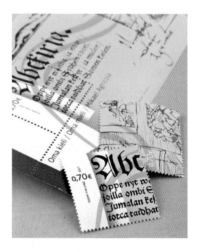

▲ Green and yellow green are the dominant hues used in these stamp designs, but the warmer red tone provides a useful accent to emphasize imagery. Design: Suunnittelutoimisto BOTH, Helsinki, Finland

◀ This poster references primary colors, even though a yellow green tone is used rather than pure yellow. Design: Rubén Moreno, Caracas, Venezuela

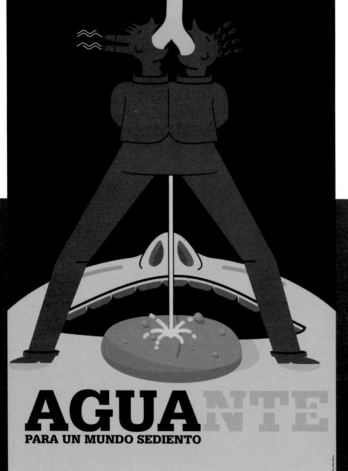

AGUANTE

PARA UN MUNDO SEDIENTO

Why It Matters

Color theory is most useful to designers because it can allow them to understand why some color relationships are successful and how to create color combinations that can be used to effectively communicate information. Color theory is a valuable tool, but it won't always lead to predictable real-world results. The basic goal when dealing with color is to produce pleasing color combinations. These groupings are commonly referred to as being in harmony. Rather than referring to a specific set of attributes, harmony has more to do with achieving the intended reaction than it does an absolute set of rules or attributes.

Color Combinations

Designers have an endless number of color schemes to choose from. These pairings can positively impact a design, but they can produce negative consequences as well. Depending on the specifications of a project, it may be appropriate to create a palette by choosing known color combinations, while in other instances, creating groupings that are based on research or the attributes of the target audience will produce the best results. The benefit of working with known pairings is that they can provide a starting point for inexperienced designers and are ideal for designers who excel at working within set limits.

These color studies show what a difference color and value can make in a composition. The first example doesn't have enough contrast. The second effectively uses an analog color scheme, and the palette of the third version of the poster works well but doesn't match the content. Design: Stephanie Boland, Rochester, New York (Courtesy of Bruce Ian Meader)

Color Wheels and Models

Artists, designers, and scientists have developed numerous models to visually compare colors and how they interact with other hues. These wheels or diagrams are commonly used to show the relative relationships between particular hues. Designers and other visual artists most often use the subtractive mixing system when creating color models because it most closely mimics what happens when paint or another pigment is put on a reflective surface. These models tend to be easiest for visual designers to understand, but there are also color wheels based on the subtractive printing process and even ones based on light. Additive color mixing closely mimics how light stimulates the eye and this system is used in screen design. Colors are categorized depending on their placement on the color wheel and on how they react to other hues. Understanding the most common groupings of colors will enable one to choose pairings that have predictable visual results.

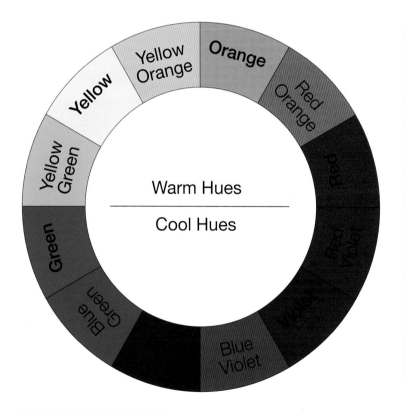

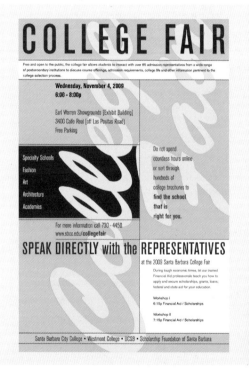

Basic color wheel: This diagram of a basic color wheel provides an excellent reference tool to see the relationships between colors when working on design projects.

Design of color wheel diagrams:
Bruce Ian Meader, Rochester, New York

Warm and Cool Temperature Colors: The color wheel is divided into warm and cool hues.

▲ Primary colors create a distinctive color palette for this college recruitment poster. Design: Alex Girard, Santa Barbara City College, Santa Barbara, California

Primary Colors

Secondary Colors

Tertiary Colors

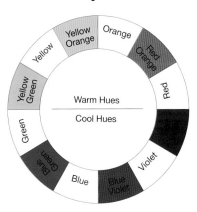

Primary colors include red, yellow, and blue and are pure hues, which are unrelated to each other. By mixing the right amount of primary colors, it is possible to create any color in the spectrum.

Secondary colors include violet, orange, and green. They are made by combining equal amounts of two primary colors.

Tertiary colors are located between primary and secondary hues on the color wheel and have more of one primary color than the other. How a tertiary color appears will depend on which primary color is dominant in the mixture.

Complementary Hues

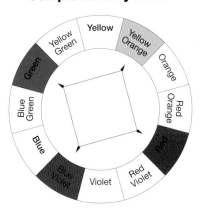

Split Complementary Hues

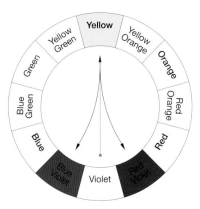

Complementary hues are any two colors located directly opposite or across from each other on the color wheel. There are a total of six pairs of complementary colors. Complementary colors have a contradictory relationship with each other. A color is both attracted to and repelled by its complement. The push/pull of the complement can be used as a way to attract a viewer's attention.

Split complementary hues refer to a primary color and two secondary colors that are located adjacent to the hues' complement on the color wheel.

▶ Split complementary colors provide the basis for the color palette for this design. Design: Matthew Brownell, Rochester, New York (Courtesy of Bruce Ian Meader)

Analogous Combinations

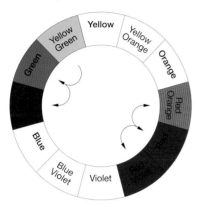

Analogous combinations refer to a primary hue and two adjacent hues next to each other on the color wheel. Analogous color combinations tend to be harmonious because they reflect similar wavelengths of light.

◀ Analogous colors make up the basis for the overall color scheme of this poster. Yellow is a bright accent against the green and blue palette. Design: Götz Gramlich, Heidelberg, Germany

Triad Harmonies

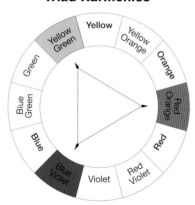

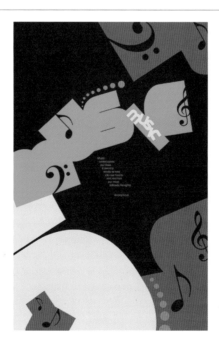

Triad harmonies are any three hues spaced equidistantly around the color wheel. Because primary and secondary colors are equidistant from each other, they combine to create triadic color combinations.

◀ A triad palette is used for this color study. Using tints increases the number of tones present in the composition. Design: Chrissy Buettner, Rochester, New York (Courtesy of Bruce Ian Meader)

Design of color wheel diagrams:
Bruce Ian Meader, Rochester, New York

Tetrad Combination

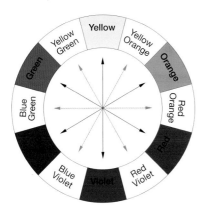

Tetrad combinations are made up of four hues, which are sets of complements or split complements.

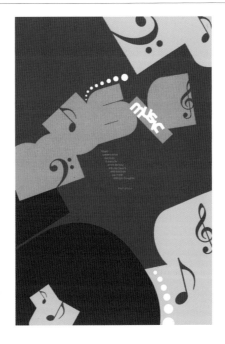

◄ This color study makes use of a tetrad palette. By using some colors as dominant tones and others as accents, it is possible to effectively incorporate all four hues within the same composition. Design: Chrissy Buettner, Rochester, New York (Courtesy of Bruce Ian Meader)

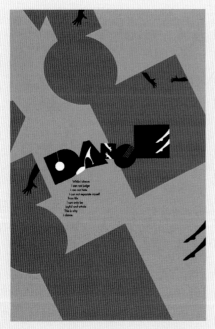

Monochromatic refers to variations of a single hue that include tints (the hue plus white) and shades (the hue plus black). Like analogous colors, monochromatic color combinations are considered to be harmonious. This may be the reason that one-color palettes are often so successful in design solutions.

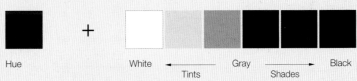

Hue + White ← Tints Gray Shades → Black

◄ A monochromatic palette is used for this color study. Using tints and shades gives the appearance of a varied and interesting color palette while saving on printing costs. Design: Kevin John Buntaine, Rochester, New York (Courtesy of Bruce Ian Meader)

Masters of Color

Johannes Itten was a *master* at the Bauhaus, in Weimar, Germany, in the 1920s and is considered to be one of the greatest teachers of color. Itten believed that while there are some predictable color relationships and outcomes, much of how artists and designers use, and audiences perceive, color is subjective and determined by context. He suggested that studying the relationships that hues have to each other and how they work in context would allow artists and designers to hone their sensitivity to color and make more meaningful choices. In the book, *The Elements of Color,* Itten noted that a practitioner can achieve successful color solutions in three different ways. The first is visually (which he called impression), the second is emotionally (which he called expression), and the third is symbolically (which he called construction).

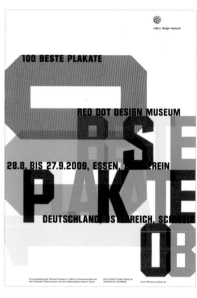

▲ The proximity of hues to each other changes how they are perceived. Here, virtual depth is created by overlaying different colored type. Design: Uwe Loesch, Mettmann, Germany

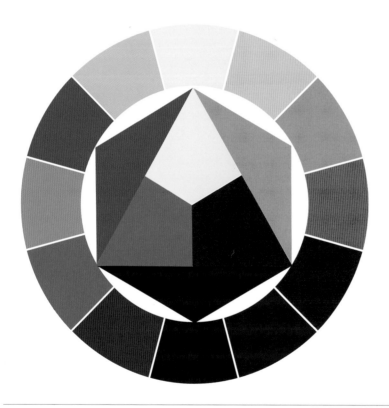

Itten's color wheel: This diagram helps show the interactions between colors and includes primaries in the middle as an indicator of how colors can be mixed to produce new hues.

Itten's ways of approaching color:
Impression (or visually)
Expression (or emotionally)
Construction (or symbolically)

Josef Albers, a legendary colorist and painter, was a student of Itten's at the Bauhaus, where he went on to teach after he graduated. When the Nazis closed the school in 1933, Albers emigrated to the United States where he taught first at Black Mountain College and then at Yale University. He worked extensively with color as an artist and educator. At Yale, Albers explored color, its relationships, and its effects on his students. He famously said that if you asked fifty students what they saw when they saw red you would come back with fifty different reds. This subjectivity can be challenging for the designer unless they understand how to mitigate the differences in perception and can create color combinations, which are more likely to achieve the intended result.

Albers focused on what happened when colors interacted with each other, as often happens when hues are placed together within a single composition. He put students through exercises that were designed to hone their ability to create effective color groupings. Both Albers and Itten believed that relatively subtle variations in color groupings and tonal values could produce interesting results and that a person's ability to make successful color choices could be improved with practice and study.

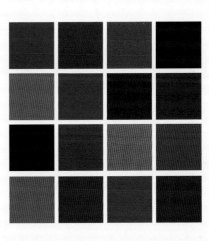

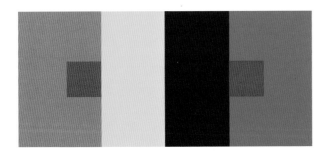

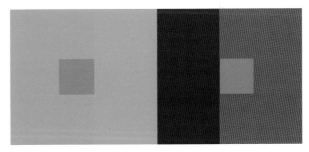

Alber's Color Studies: Joseph Albers created numerous color studies to show the relationships between hues. Here the small squares in the center of the composition are the same color but appear to be different because of the colors that surround them. These examples show how a viewer's perception of color is relative and will always depend on what it is next to.

Color Exercise 1

Exercises 2 and 3 are taken from Albers' classic book, *The Interaction of Color,* and are designed to test a person's ability to perceive value in color. Albers believed that value was just as important as hue and intensity.

Using Color Aid paper, students begin by selecting four values of two different colors, preferably colors that are on opposite sides of the color wheel. The goal is to match the values of the hues as closely as possible. Students are asked to superimpose one set of the four colors inside the other set, and vice versa, to show the success of their choices.

Color Exercise 2

This project is designed to test a person's ability to perceptually "mix" color. Students are asked to select two colors that have different values and hues. Then they are asked to select a third color that they perceive to be the color that would be created if these two colors were mixed. Finally, the students are challenged to select a fourth color that will give the perceptual effect of optical transparency.

▶ Color study using Color-aid paper: Briana Brown, New York City (Courtesy of Paul Fabozzi)

▼ Color study using Color-aid paper: Johana Muñoz, New York City (Courtesy of Paul Fabozzi)

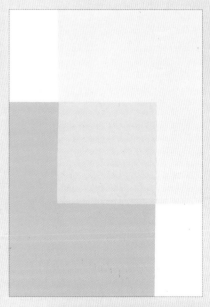

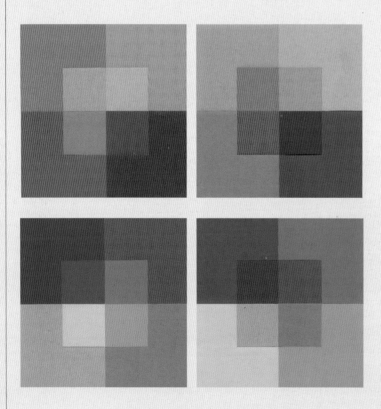

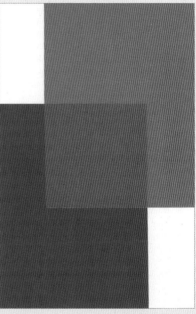

▲ Color study using color-aid paper: Brett Kalwarski, New York City (Courtesy of Paul Fabozzi)

◀ Color study using color-aid paper: Kitty Yeung, New York City (Courtesy of Paul Fabozzi)

Bezold Effect

This project was designed by Paul Fabozzi to illustrate the Bezold Effect. Wilhelm von Bezold (1837–1907) was a German scientist who was involved with textiles, and in the course of his research, he noted that a single color change in a pattern affected the appearance of all the remaining colors. The project illustrates how much the overall visual effect of a group of colors can be changed by replacing one of those hues.

a. Choose four colors of different values that work together. It is important to be sensitive to whether the colors absorb or reflect light (it is difficult to have more than one reflective color in a successful grouping of four colors).

b. Test the colors for proper value balance by placing colors next to each other.

c. Once a satisfactory group of four is chosen, change the overall visual effect by replacing one of the colors. Then replace that color again, creating three combinations.

d. To show how the colors will react with each other in a compositional space, the three combinations are used in a simple design that is made by dividing a rectangle so that the shapes share surface edges with other shapes as frequently as possible.

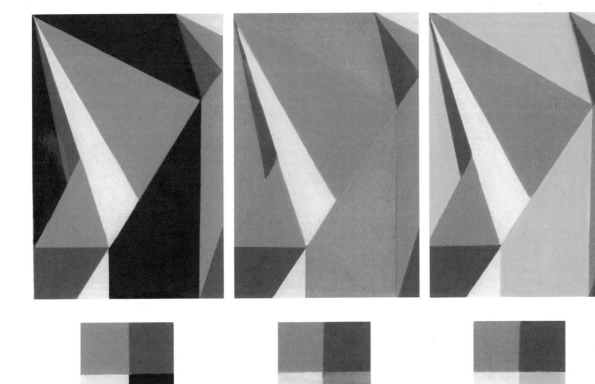

▲ Color study using Color-aid paper: Kitty Yeung, New York City (Courtesy of Paul Fabozzi)

Achieving Harmony

The choices one makes when selecting colors is often referred to as trying to achieve "color harmony." Rather than a strict set of rules, harmony suggests a pleasing or displeasing combination of hues in relation to an overall composition. Harmonic pairings can be made up of colors that have similar intensity, or they may include tones that sharply contrast each other. Whether certain hues create a harmonic palette remains somewhat subjective, but color theory offers some reasons why particular colors work together better than others. Color groupings are always affected by other elements in the composition, such as image, type, format, and even the content that is being communicated. In most cases designers are trying to achieve attractive or pleasing color combinations, but in some instances displeasing or non-harmonic combinations may help a designer realize her desired result.

One of the main tenets of color theory suggests that our vision is always trying to achieve equilibrium or to arrive at neutral. Theorists have proposed that a person's perception of color can be influenced by a phenomenon in which the brain creates a complementary afterimage of a color. This idea is supported by several experiments that show that if a person stares at one block of color and then quickly looks away, he will see the complement of that color. The implication is that the eye is always searching for symmetry or to find the balance, which comes when a hue is combined with its opposite.

▲ By using tints and shades, a complementary-based palette is visually engaging and sophisticated. Design: Subcommunication, Montreal

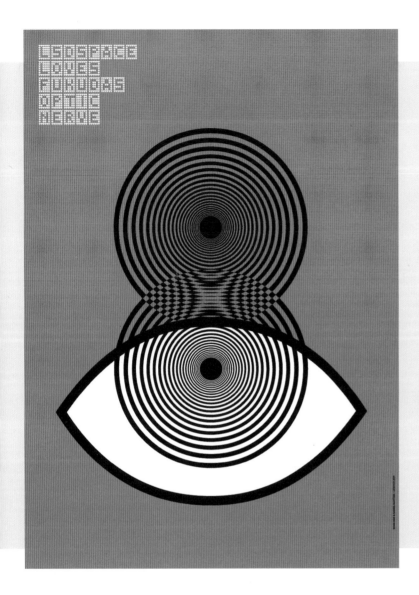

◄ Complementary colors and illusion create an eye-popping design. Even though the composition doesn't encourage harmony, the eye's natural desire for balance is fulfilled because the complements will create a neutral when mixed.
Design: LSDspace, Madrid, Spain

The reason why the brain produces afterimages isn't fully understood, but one explanation proposes that gazing at a color causes the color receptors in one's eye to become fatigued, and in an effort to restore natural balance, these receptors create a complementary afterimage. The "color" produced is the same value and intensity as the original hue. A designer or artist can use the brain's desire for *balance* to their advantage by using hues, which, when combined, will create neutral tones. This theory can influence how color is used in design because harnessing the eye's natural tendencies can allow the designer to more accurately predict how a viewer will experience a visual composition.

Interaction and Proximity

A viewer's perception of color will always be determined by what colors are present elsewhere in the composition. A white square on a black background will appear to be larger than the same size black square placed on a white background. Similarly, a light gray will look lighter on a dark background than it will on a white background. In situations of simultaneous contrast, how a color is perceived is altered by what other colors it comes in contact with. For instance, red on green can produce a ghosting effect. Before placing two colors next to or on top of each other, the designer should consider whether the colors will be subject to simultaneous contrast and whether that interaction may change the way that content is perceived.

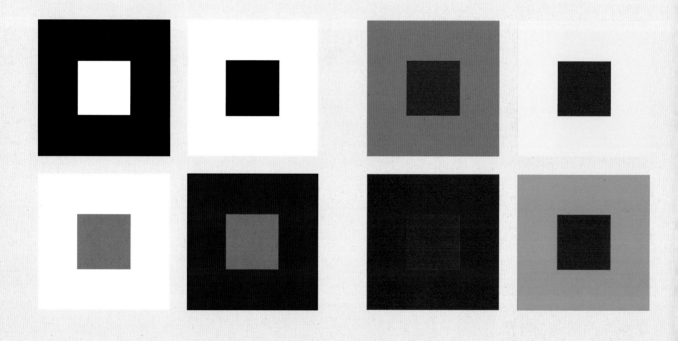

▲ This nontraditional Christmas card is a perfect example of how differently one perceives color depending on what hues are next to each other. Design: Domingo Villalba and Yessica Silvio, Caracas, Venezuela

▲ Yellow and purple visually vibrate against each other, and each color makes the other more noticeable. Design: Horacio Guia, Caracas, Venezuela

Choosing a Color Palette

Many systems can be used to select hues for a successful color palette. Which one a designer uses should be based on the specifications of the project, some degree of trial and error, and personal preference. Color variations can be derived by mixing a hue with white (which produces tints) or with black (which produces shades), or by mixing one color with another to create a completely different hue.

Designers may embrace the intensity produced by a palette that includes numerous colors, or one may decide to limit the number of colors used in a project. Limited color palettes have several benefits. If a job will be produced using offset printing, a one- or two-color job will result in significant cost savings for the client. Compositions created with limited color palettes tend to stand out in an oversaturated market. Using models and known systems is an excellent way to start making effective design decisions.

In most cases, a designer will use a built-in "color picker" in a software program to specify particular colors. However, in some cases, a job may require the selection of colored paper or other materials for print production. Pantone and/or other swatch books (see page 40) and online applications, such as Color Scheme Designer (see page 118), can also help with color selection.

▲ Using one color plus a tint is a great way to achieve visual interest while keeping a color palette extremely limited. The combination of orange and white is sure to be noticed, even on shelves filled with similar products.
Design: Maris Maris, New York City

▲ Fully saturated hues of orange and purple have been applied to the photos as well as the shape and type. This unifies the composition while still presenting a clear visual hierarchy.
Design: Subcommunication, Montreal

The Dominant, Subordinate, and Accent System

One successful system of picking colors relies on the use of dominant, subordinate, and accent hues. This model provides both structure and variation, and offers nearly limitless options. Begin by choosing a dominant tone that complements the message. Then choose one or more subordinate colors. Lastly, select an accent that can be used sparingly in the design and will create a harmonious combination with the dominant and subordinate tones.

A good way to test whether color pairings are effective is to vary one hue at a time. Try altering the palette by replacing one of the original hues with its complement. Then try replacing it with a neutral. Alter saturation and see if any of these variations results in a more pleasing combination. Slight variations make a big difference, so it is important to test several "seemingly" successful combinations on the project content before making a final decision.

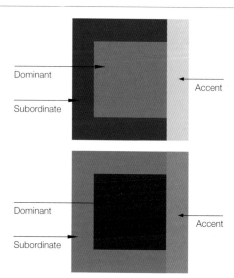

Dominant

Subordinate

Accent

Dominant

Subordinate

Accent

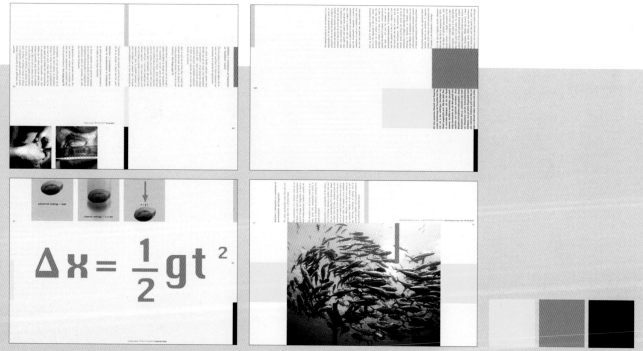

▲ These book spreads provide an excellent example of the dominant, subordinate, and accent system in practice. The palette is made up of orange, yellow, and black. In most cases, orange is used as the dominant tone, but the system allows for enough variation that yellow and black can be dominant on some pages as well. Design: Uwe Loesch, Mettmann, Germany

Meaning-based Method
for Harmonizing Colors

This method will create a palette from any base color. It is a good technique to use when a job requires one specific hue to be part of an overall palette. Start by choosing a color that elicits the correct response and adheres to the client's message. Then add a complement of the same value and intensity. Now take these two colors and transform them into their opposites in value and intensity. This process is easy when working in a software program that has a color picker or by using an online application such as Color Scheme Designer (colorschemedesigner.com; see page 118). The resultant colors will be harmonious. One can make slight alterations to the shade or tint and then choose which hues in the combination will be appropriate as dominant and accent colors.

To further experiment using this method, try replacing one of the colors with several different hues, one at a time, to see if the resultant combination creates more pleasing visual relationships.

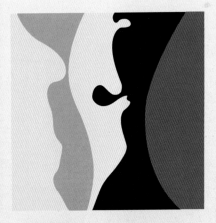

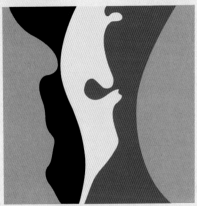
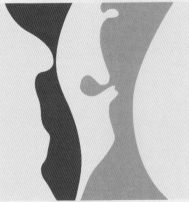

▲ The color used in these compositions is picked up from the image. By repeating it, the designer ensures that the composition seems unified and that the image will be the focal point. Design: Paone Design Associates, Philadelphia

◀ Choosing the right colors for a project is only the beginning. It is also important to test how hues interact with one another. Placing certain colors next to each other can add emphasis and show importance. It can also change how a composition is perceived. In these color studies, where color is placed affects which shapes seem to advance and recede.

Repetition or Reoccurrence

Repeating and/or showing the reoccurrence of one or more hues and/or its shades and tints is a great way to unify a composition or to show similarity among multiple components. This system can be used with almost any color combination but is likely to be most effective and/or most noticeable when used with limited palettes.

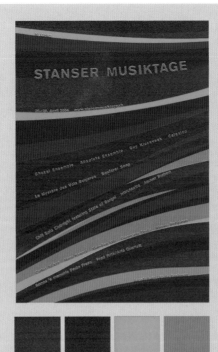

▲ Repeated color sequences can reference motion or depth and create the appearance of an optical illusion. In real-world projects, sequences are usually most effective when they are varied and/or are used to create a pattern.

◀ By using shades of red and magenta as well as the colors at their full strength, the designer is able to make a harmonious palette out of an unusual combination of colors.
Design: Melchior Imboden, Buochs, Switzerland

Progressive

This system refers to a sequence in which a color or colors change in constant steps from dark to light or light to dark, and results in the appearance of continual progression. Progressive value shifts are particularly good at producing color palettes that include three or more hues.

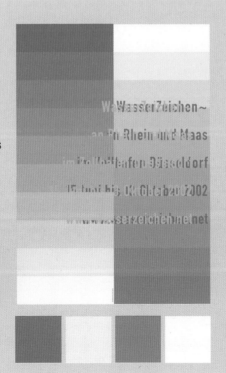

◀ Progressively lighter tints of blue create a harmonious color palette while also producing interesting compositional space.
Design: Uwe Loesch, Mettmann, Germany

One-Color Palettes

One-color palettes can be a great way to reduce the cost of printing and to create simple yet effective layouts. When choosing this system, the designer often starts with an intense or bright hue. Then its tints and shades can behave like subordinate and/or accent hues. It is also possible to use only one value of a color and let the paper or "ground" create the variation within the composition. If the goal is to lessen the cost of producing print design, colored or textured paper can give the appearance of more than one color, even though only one printing plate is used. One-color palettes are also a good choice if the final design solution will exist in a busy visual environment or when the end result will be seen on screen.

▲ Even though cost savings is one of the main reasons to use one- or two-color palettes, limiting the number of colors used in a composition will sometimes draw attention to a particular element or area of the design.
Design: Bob Wilkinson, Abuja, Nigeria

▲ When applying color to pages, a designer can choose a paper or other material that comes with its own color or texture. This is a great way to make one- or two-color printing more colorful.
Design: Shual Studio, Ramat-gan, Israel

▲ The mastheads of these magazines change color, but the rest of the covers are produced in full color. Limiting the hues used in the masthead allows the issues to be easily differentiated.
Design: Seitaro Yamazaki (Macla, Inc.), Tokyo

▲ The tint of the dominant blue is used as an accent, and the white of the paper gives the appearance of a two-color job. Design: David Frisco, New York City

Two-Color Palettes

Two-color palettes can produce highly effective graphic design while still allowing abundant creative freedom. Two-color combinations may include tones, which have well-known relationships such as those illustrated in the color wheels (see pages 19-21). They may rely on one hue to be dominant and another to be subordinate and they may even include unusual or quirky combinations that are designed to attract attention rather than be harmonious. Two-color palettes provide great cost savings for offset printing, while allowing for greater flexibility than one-color or monotone palettes.

◀ This poster shows how much can be accomplished using simple elements and tints of the dominant color. Design: Adrián Fernández González, Asturias, Spain

▶ Though this composition technically uses three colors, the effect is still of a two-color design. The black stands out against the yellow, and the slight gradient keeps the background from looking flat. Design: STUDIOKARGAH, Tehran, Iran

▼ Using red and black with the white as an occasional accent allows the type to stand out and the negative space to be just as interesting as the positive. Design: Domingo Villalba and Yessica Silvio, Caracas, Venezuela

▲ When simplicity is key and a composition relies on shape, two colors can be extremely effective at communicating a message and catching a viewer's attention. Design: Juan Carlos Darías Corpas, Caracas, Venezuela

Black and White

Just because a design doesn't use color, doesn't mean it can't be powerful and effective. Choosing to use only black and white may be the result of budgetary constraints or it can be a specific design decision. Black-and-white design solutions are very effective at visually communicating information to an audience.

▲ When a composition relies on shape and type, limiting one's color choice to black and white adds emphasis. Design: Seitaro Yamazaki (Macla, Inc.), Tokyo

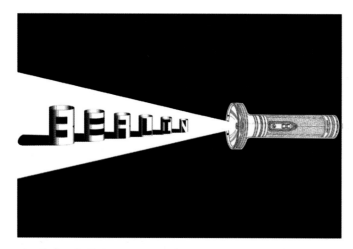

▲ Black and white has two purposes in this composition. The black background provides optimum contrast and the white, in the shape of a beam of light, continues the visual metaphor of the flashlight. Design: Garth Walker, Durban, South Africa

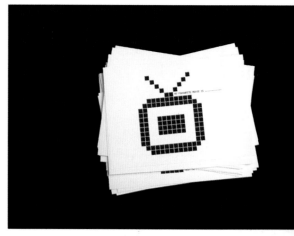

▲ This illustration uses a style that is reminiscent of individual dot pixels, which is perfect when paired with the text "my favorite movie is…" Shape and text are able to communicate the message without the addition of color. Design: 2FRESH, London, Istanbul, Paris

Different Blacks

When a large area of a composition is black, the printer will usually ask the designer to use a special combination of CMYK to produce rich "print-friendly" black. This combination is created by mixing 60 percent cyan, 40 percent magenta, 40 percent yellow, and 100 percent black ink and can be specified with the color picker in design software. The resultant color-rich black provides good coverage and is pleasing to the eye, but it should only be used on large areas of black color. Black body text should be specified as 100 percent black or K. It is helpful to create swatches of text black and rich CMYK black so that it is easy to toggle between the two.

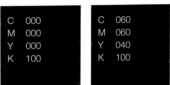

C	000		C	060
M	000		M	060
Y	000		Y	040
K	100		K	100

 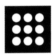

◀ ▼ This identity for a TV station can be customized using a variety of visual elements. The designers chose to use only black and white so that the piece would stand out in a full-color digital environment. Design: Lava Graphic Design, Amsterdam, Netherlands

Color Systems

How color is created depends on where it will be seen and how a communications piece will be produced. RGB, CMYK, and Pantone are three of the most commonly used color systems in design, but they are not the only ones in existence. In some countries, other matching systems such as TOYO, ANPA, or DIC may be used. Fortunately, software programs like Adobe Photoshop, Illustrator, and InDesign all include numerous color profiles and systems in their swatch libraries.

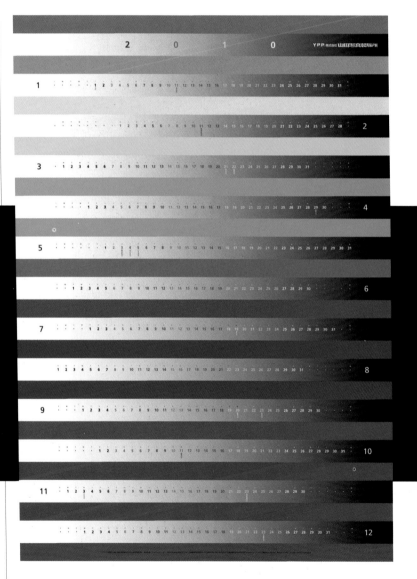

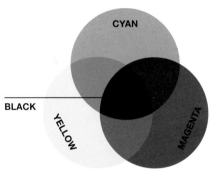

◀ This poster highlights the benefits of using a multicolored palette as a design element in and of itself. Since this poster would be printed, CMYK is the best color system to use.
Design: Katsui Design Office, Tokyo

CMYK is a four-color subtractive process, which includes the colors cyan, magenta, yellow, and black. The process is considered to be "subtractive" because the inks that are used for printing subtract, or mask, the background (which is usually the white of the paper) using a halftone dot pattern. Colors are produced by combining CMYK ink colors and partially, or fully, printing them on a white background. CMYK is used in offset lithography, and in most cases, a designer will be required to change all graphics and imagery to CMYK before sending files to a printer.

Standardized SWOP guides are used in the United States, Europe, and Asia. They show the percentage of CMYK values that are needed to create a particular hue to ensure that the colors specified will match the finished print product. How color appears on print media will also be determined by the paper stock (whether it is coated, uncoated, or matte), and whether a varnish or aqueous coating has been applied over the ink.

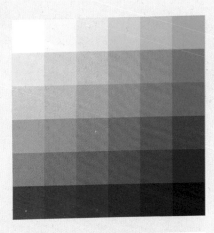

▲ This image has been separated into distinct channels of each CMYK color. Printers sometimes maximize the amount of black in the separation process as a way to save ink. In such cases, the black plate will be more saturated than in this example.

Pantone is a proprietary color system that allows printers and designers to accurately communicate and produce specific color choices. The Pantone Matching System allows a designer to select and specify a particular Pantone color that will be matched exactly by the ink used by a commercial printer. The Pantone Formula Guide is a three-guide set consisting of 1,114 solid Pantone colors, which can be used on coated, uncoated, and matte stock. The guide is extremely popular and is used by the designer to specify the color and by the printer to create the corresponding ink formulas needed to produce each color on a specific type of paper.

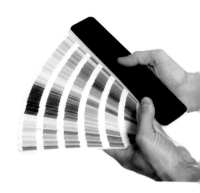

▲ Specifying a Pantone color will ensure that print materials, like these, are all produced using exactly the same color orange. Design: Suunnittelutoimisto BOTH, Helsinki, Finland

▲ Bright colors and lively shapes combined with simple white type create a vibrant composition. Design: Sebastian Guerrini, La Plata, Argentina

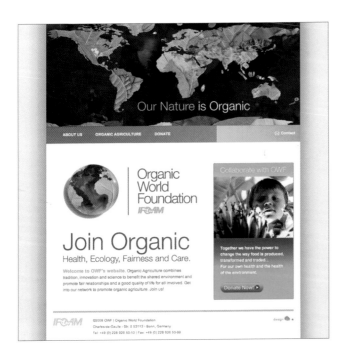

◀ Green is commonly associated with the environmental movement and organic or otherwise healthy products. This website for the Organic World Foundation uses green as a component in the design but also incorporates rich orange, yellow, and blue tones, which add value and originality. Design: Sebastian Guerrini, La Plata, Argentina

RGB is an additive color system that uses the base colors red, green, and blue to produce a wide variety of colors. In the RGB palette, white is the additive combination of all the primary colors and black is produced by the absence of light. Screen- and display-based design uses the RGB color system and even some large-format printers use RGB-based color interpretation systems or profiles that will then print with CMYK ink. TV's video screens, monitors, mobile devices, and cameras all use the RGB system.

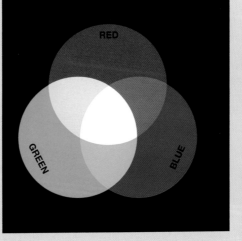

Color Forecasting

Choosing successful color combinations is big business. In the fashion and interior design industries, specialists are often asked to help predict which colors will be popular at a given time or for a particular audience. Color forecasters create reports on which colors, textures, and trends are likely to be widely adopted and sell well in future seasons. The information collected by these companies can be accessed by purchasing reports or by subscribing to ongoing memberships. The Color Marketing Group (www. colormarketing.org) assists profes-sionals with industry- and location-specific color information and is a resource for color trends. The Pantone Color Institute (see www. pantone.com) also publishes seasonal forecasts that are available in short form online and as download-able PDFs free of charge. In most cases, choosing colors for a specific graphic design job is more likely to be determined by the message and the target audience than by seasonal trends. However, in certain instances, using color forecasting may help produce current and timely color choices.

▲ This design for "special wallpaper" is unique and colorful. This kind of palette will most likely appeal to a buyer with specific taste who doesn't care about seasonal trends.
Design: Answr Inc., Tokyo

▶ Spreads showing different types of tudungs (traditional head coverings) feature diverse colors and patterns and are made even more interesting by placing the models on multicolored back-grounds. Changing the color and pattern of a common clothing item is one way to keep it fresh and new season after season.
Design: Cheah Wei Chun, CLANHOUSE, Singapore

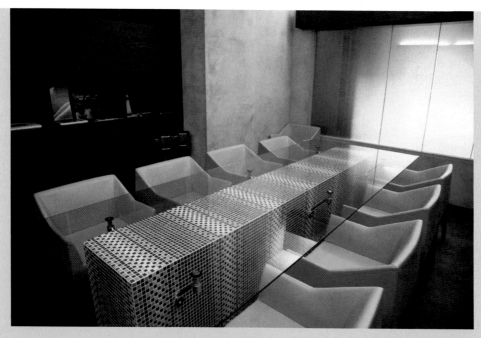

▲ Forecasting is used by the interior design industry to anticipate which colors and combinations are likely to be popular in the future. However, when one is creating an interior space that is meant to last, it is usually best to use a color palette that isn't time specific and will hold up to changing tastes.
Design: Seitaro Yamazaki (Macla, Inc.), Tokyo

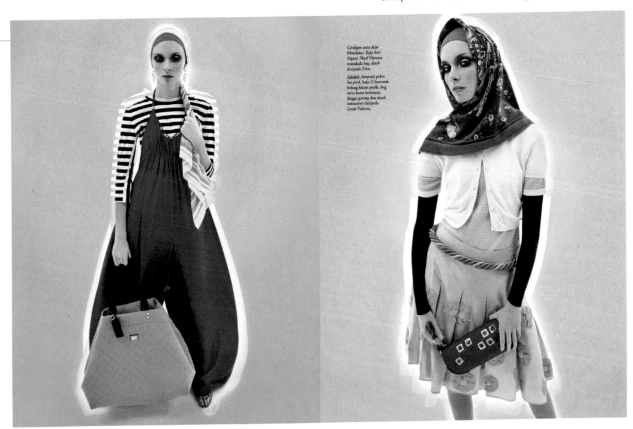

*Cardigan serta skirt
Moschino. Baju knit
Aigner. Skarf Hermes
manakala beg, clutch
daripada Dior.*

*Sebelah: Jumpsuit polos
ber-pink, baju-T bercorak
belang hitam putih, beg
serta kasut berwarna
jingga garang dan skarf,
semuanya daripada
Louis Vuitton.*

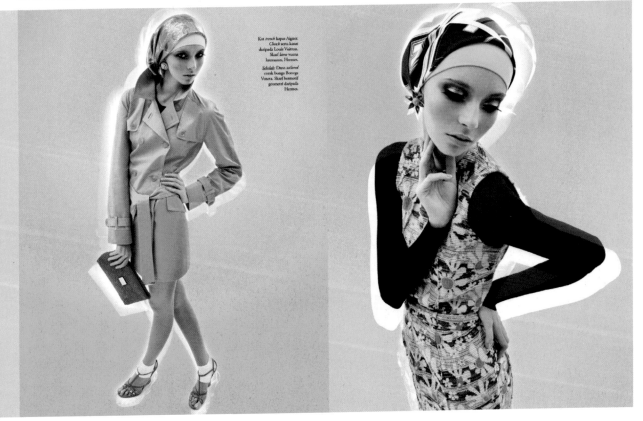

*Kot trench kapas Aigner.
Clutch serta kasut
daripada Louis Vuitton.
Skarf lane warna
keemasan, Hermes.*

*Sebelah: Dress tailored
corak bunga Bottega
Veneta. Skarf bermotif
geometri daripada
Hermes.*

Color Blindness

Color blindness or the inability to see certain colors occurs predominantly in men and affects about 10 percent of the population worldwide. It is usually genetic. It is incurable, and how it manifests can vary from person to person. People with color blindness are often unable to distinguish between certain colors. Some people are completely color-blind (this condition is extremely rare), but most have difficulty seeing one or more colors, such as red and green. If a person is aware of the problem, he may compensate by learning to guess the identity of colors or by only wearing tones and shades that he recognizes. The U.S. Army found that men with color blindness were able to see "camouflage colors" better than those with normal vision. Not seeing every color may have occasional benefits, but for most people, color blindness is an inconvenience and may cause social embarrassment.

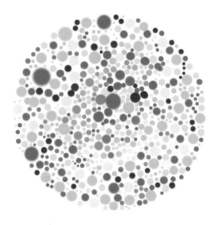

▲ This graphic is based on the Ishihara tests for color blindness, which were developed to identify whether a subject has problems seeing red and/or green. Those with color anomalies may not be able to identify the shapes in the dots or may see a different pattern from a person with full vision.

COLORadd®
color identification system

Inspired by the idea that design can have a positive impact on people's lives, designer Miguel Neiva created ColorAdd (www.coloradd.net), a project that helps people who suffer from color blindness. Neiva's solution targets people who might need to use color in a professional setting, such as design, fashion, interior design, or architecture, but it also provides a system to make color choices easier in users' everyday lives and for navigational tools such as maps. The project is still in the concept phase, but Neiva has applied his graphic system to a variety of applications including hospital materials, maps, school supplies, and clothing tags.

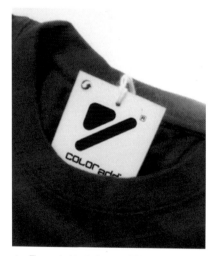

▲ The project includes an additive graphic symbol system for identifying colors, which can be applied to clothing tags and other product labels. The graphic elements can be integrated into users' visual vocabularies and they can be applied in small dimensions in a variety of settings. Design: Miguel Neiva, Porto, Portugal

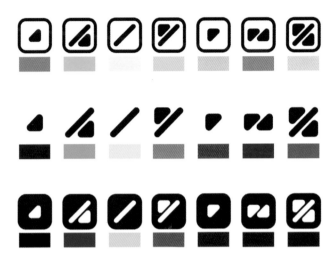

▲ The goal of ColorAdd is to provide a public service and to give autonomy to people who suffer from color blindness.
Design: Miguel Neiva, Porto, Portugal

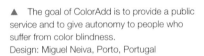

Super Sight

Humans can perceive millions of distinctive colors, but some of us see better than others. Scientists have found that a small number of people can actually see another cone between red and blue. Known as tetrachromats, these women may be able to perceive 100 times more colors than most of us. This kind of super color vision is only possible in women because two cone cell pigment genes are located on the x chromosome. There are relatively few tetrachromats (about 2 percent to 3 percent of women worldwide), so there's no need to design for *super color vision* just yet.

Color and Texture

Texture is frequently overlooked as a variable in design applications. It can be used as a background, to fill a shape or a letterform, or even as an accent. Combining color and texture can enhance a layout, achieve greater visual interest, and aid in communicating a mood or message. Texture is used by designers who want to give something a handmade or unusual look and it may come from photographs, from the material on which pieces are printed, or by creating an overlay of a seemingly unrelated visual. When combined with color, texture can make an overall design feel more individual and provide a specificity that will be attractive to some clients.

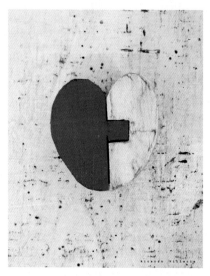

▲ Red is a typical color to use with the "heart" shape, but the use of photographic texture keeps this composition from being predictable. Design: Ricardo Villoria, Langreo, Spain

▲ The design of this magazine spread relies on the visual texture created by restaurant menus. The designer wanted to highlight the fact that similar colors and fonts are used by many pizza places. Design: Martijn Oostra, Amsterdam, Netherlands

◀ Repeating part of the logo creates a textured pattern, which can then be applied to the other components of the identity system. The pattern adds enough visual interest that it isn't necessary to use more than one color. Design: 2FRESH, London, Istanbul, Paris

Managing Expectations

We all have expectations of when and why certain colors should be used. It is up to the designer to judge whether these expectations will support the delivery of a message or if another color combination should be explored. It is important to acknowledge that subjectivity is always involved when working with color. Viewers perceive color differently. Using high-intensity colors can make the difference between a well-attended and not-so-well-attended event, while applying neutral or calming tones to quiet content will meet audiences' expectations of some products and services. Deciding on a color palette is an integral part of the design process and should be considered at the very beginning of a project.

◄ ▶ Street signs use bright, predictable colors in order to quickly communicate important information.

Things to Consider:

1. Are there existing systems or models for choosing color combinations that can be applied to this particular project?

2. Do one or more colors need to be used because they match a client's existing identity or overall brand strategy?

3. Do specific hues or values match the target audience's expectation of a product or service? If so, should these be incorporated into the color palette?

4. Would the composition or the message benefit from intense colors as dominant tones or should they only be used as accents?

5. Would the addition of neutrals strengthen a color palette? Can they be used as dominant colors?

6. Can color come from paper choices or other materials used in production? This is particularly important to ask when dealing with signage, environmental graphics, or packaging.

7. How do your budget, production, or media specifications affect color? For instance, on low-budget projects, one- or two-color compositions should be considered. It's also important to find out if a full range of colors can be produced if the output will be on a handheld device or mobile phone.

Chapter 2
Form and Space

Form and Space

It is the combination of content, form, and ideas that come together to create graphic design. How an element appears within a composition is determined by its placement, scale, color, balance, repetition, and other visual variables. By manipulating form, it is possible to create an optical illusion and to make a two-dimensional space seem like it has depth. Elements can even appear to recede or advance. They may be static or give the impression of movement, but they are always governed by the compositional space.

Color can help the eye find a focal point and it can suggest where a viewer should focus. It can affect the spatial relationships on a page and can emphasize content and suggest movement and depth. Color relationships can cause a viewer to experience space and information differently. By choosing specific hues and by altering value and intensity, a designer can enhance the message being communicated.

▲ Use of light and subtle color allows the images projected on these screens to draw viewers in and shows them where to focus. Spatial relationships are suggested, even though the images are two-dimensional. Design: Shual Studio, Ramat-gan, Israel

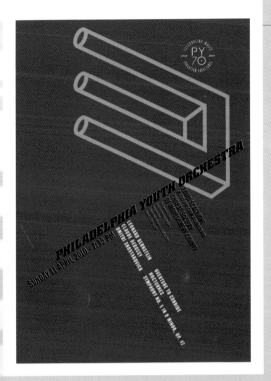

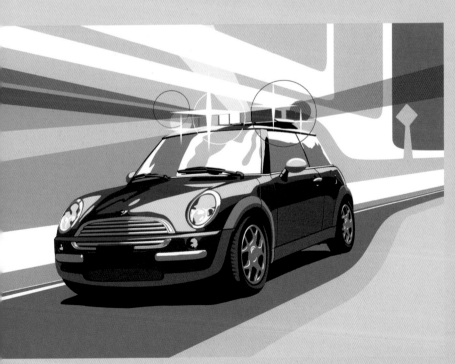

◄ The form of the "devil's pitchfork" gives the illusion of depth in this poster for the Philadelphia Youth Orchestra. Design: Paone Design Associates, Philadelphia

► ▼ Like a fun-house mirror, this composition plays with the viewer's perception of space and depth by employing undulating lines and two vanishing points. The repetition of color adds emphasis to the illusion. Design: Melchior Imboden, Buochs, Switzerland

▼ Skillful use of color makes this illustration seem three-dimensional. By matching the red used in the composition with the tone that is commonly associated with Mini Coopers, the designer taps into viewers' previously held associations. Design: Ames Bros, Seattle

Foreground and Background

A message can be most easily understood if there is adequate contrast between elements in the foreground and background of a composition. These spatial relationships can also reference depth and distance. It is particularly important to differentiate text elements from their background since a lack of contrast can make it difficult for viewers to read content. Altering the color of text, shapes, or imagery is an easy way to make certain items appear to be in front of or behind others. By placing components according to their relative importance, a designer can achieve visual balance and encourage the message to be read and/or understood by the audience.

The specific tone and intensity used for the background is important to the success of a composition. If the background color is too intense, or bright, it runs the risk of being overpowering. On the other hand, if a muted or dull tone is used for the background, the foreground elements should offer contrast by being lighter, brighter, or more intense. It is desirable to achieve a balance so that the background complements, but does not overwhelm, the foreground, and so that the most important elements stand out.

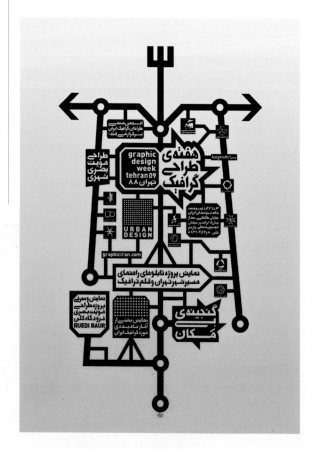

▲ Since most of the colors used here belong to a similar value range, the type acts like texture and the bright red elements stand out against the background. Design: STUDIOKARGAH, Tehran, Iran

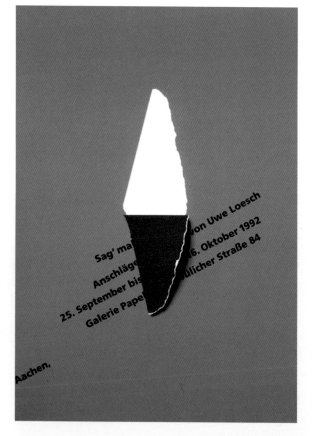

▲ Bright red stands out and creates real foreground space because it is offset with the darker color of the shadow and the cool blue green background. It is the contrast between warm and cool tones that makes this composition stand out. Design: Uwe Loesch, Mettmann, Germany

◀ The blue green background contrasts the warm hues used for the type and makes this simple composition exciting and engaging. Design: Alex Girard, Santa Barbara City College, Santa Barbara, California

▼ This eye-catching combination may remind viewers of a road sign, but it is sure to stop them in their tracks.
Design: Uwe Loesch, Mettmann, Germany

▼ In this poster, the foreground, middle ground, and background are created with color. Using a cool blue in the background makes the silhouetted figures appear to be in front of the other multicolored elements.
Design: Susana Machicao, La Paz, Bolivia

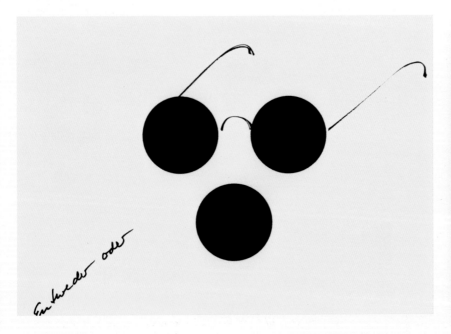

Elements of Design and Their Variables

The fundamental elements of design such as line, point, and shape provide the backbone for many communications solutions. Since the eye is drawn to what it sees and perceives most easily, a viewer will often notice the hues and tones of a composition before anything else. When color is used in combination with these elements, it can provide a strong visual statement. These variables may be used on their own, together, or in combination with other components such as type and image.

Shape

When used in conjunction with color, shape may reveal meaning and make a composition more appealing to an audience. Shape is also an important tool when laying out multipage documents. The combination of color and shape can be used to break up content and/or create a repeating structure that encourages a viewer to turn the page and keep reading the text.

▲ Alternating blue and pink dots on the top half of the composition creates an eye-catching pattern, and the repetition of pink draws the eye down toward the text below. Design: LSDspace, Madrid, Spain

▲ An identity package can be based on the repetition of shape and color. In this example for Stylecraft, the system allows for a tremendous amount of variation while retaining an overall visual consistency. Design: THERE, Surry Hill, Australia

◀ Small tonal variations in grays seem greater because they have been combined with sharp-edged triangles. The two accents of red add a shock of emphasis that will keep viewers interested. Design: Uwe Loesch, Mettmann, Germany

 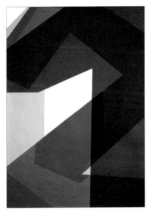 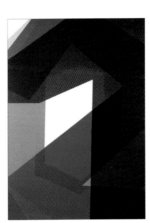

◀ Color affects how we perceive shapes in a composition. When the color of these shapes is altered, some seem to recede into the background while others appear to advance forward on the page. Trying several different combinations of color for each project is more likely to produce successful color relationships.
Design: Melchior Imboden, Buochs, Switzerland

▲ These shapes seem to jump off the page because the designer has skillfully combined compositional elements with intensely bright hues.
Design: Gotz Gramlich, Heidelberg, Germany

▶ Elements in this identity package are differentiated by shape but are unified by color.
Design: Maris Maris, New York City

Lines

Lines, which are often called rules in graphic design, are a common visual element. They can add emphasis, imply movement, denote space, add depth, and reveal structure. If the lines are used to reveal the message, then the combination of color and line will usually sustain a reader's attention long enough for information to be read. On the Web, lines or colored rules, are often used to give pages structure. In motion graphics, lines may be in motion and can be used together with text, image, and shape to create a coherent overall design within a multidimensional moving piece.

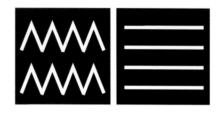

The Skinny on Lines

Zig-zag lines denote agitation, instability, and movement.

Straight lines are a calming, soothing, and a relaxing element within a composition.

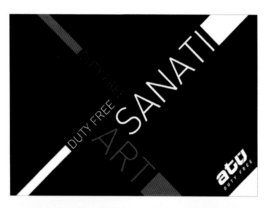

◄ Less is often more. In this second composition advertising duty-free shops, the limited color palette and strong use of line provide grounding points for the addition of full-color images.
Design: 2FRESH, London, Istanbul, Paris

▼ Bright colors and line-based type create an engaging combination that seems to reference movement, even at a glance. There is no doubt that viewers will notice this poster, even in a busy visual environment.
Design: 2FRESH, London, Istanbul, Paris

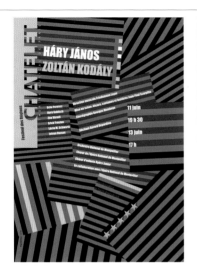
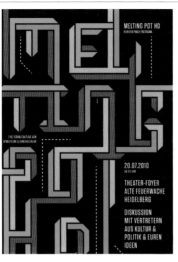

◄◄ A skillful use of line adds depth to the two-dimensional space and provides handy spaces for supporting type to be added. Design: Rudi Meyer, Yerres, France

◄ Lines effectively determine the visual hierarchy of this composition, and color adds emphasis and reinforces the message. Design: Götz Gramlich, Heidelberg, Germany

▼ Thin lines are woven together into a compositional element that acts like a subtle background illustration. The light green and magenta palette creates an unusual but seductively harmonious color relationship. Design: Subcommunication, Montreal

◄ These covers use hand-painted lines as a simple element to show expressive difference. The brightly colored vertical rules provide a space for the type and create a structure that can be repeated.
Design: Finn Nygaard, Fredensborg, Denmark

Scale

Scale is one of the easiest ways to convey relative importance. By making one element bigger, a designer can ensure that it will be noticed more quickly. Similarly, the size of some visual elements can be reduced so they don't dominate the composition. By combining color and scale, the designer is able to make certain elements stand out from the rest. Color and scale are often used together when working with type. Large, brightly colored letterforms provide a foundation for great typography. By making some typographic elements bigger and varying their color, type can be used in place of imagery.

Contrast

Contrast may be applied to color relationships by altering the value of a hue or by choosing a particular tone that has more or less intensity. Contrast is always relative. Black and white has the highest degree of contrast, but a bright aqua-green will achieve a high level of contrast when it is placed against a darker tone such as brown or dark gray.

Contrast is a great way to get a viewer to pay attention to a particular element or an entire layout, but it is also possible to overdo how much contrast is present within one composition. A little contrast goes a long way. Too many elements with contrasting tones may be irritating and, in some cases, may even confuse the importance of elements within a composition.

▲ Using two bright colors together can be overwhelming in some instances. But this composition of large letterforms manages to be quirky and fun rather than irritating.
Design: Götz Gramlich, Heidelberg, Germany

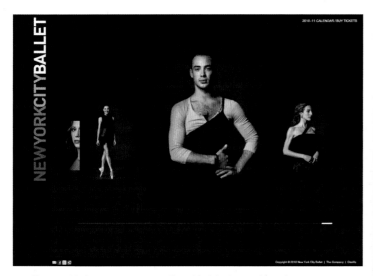

▲ Photographic images are contrasted by a black background, creating a sense of drama, which is perfect for a site dedicated to individual dancers.
Design: Marc Rabinowitz, New York City

▲ The giant quotes stand out against the red background. Their size and the contrast between the black and gray and red create dynamic compositional spaces in which the other elements can be placed.
Design: Paone Design Associates, Philadelphia

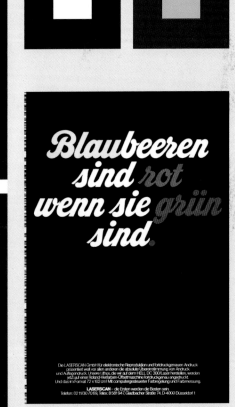

▲ The letterforms are huge, but it is the bars of orange that maintain the hierarchy and make the most important information stand out in this composition. Design: Rudi Meyer, Yerres, France

◄ The contrast between the bright blue background and the even brighter red image in the foreground almost seems to vibrate.
Design: Ames Bros, Seattle

▲ Changing the color of several words can make parts of a message stand out, especially when the type is placed on a dark background. The hints of color on the left side tie all the colors together.
Design: Uwe Loesch, Mettmann, Germany

Color and Image

It is said that an image is worth 1,000 words, but in graphic design, imagery is rarely used without the accompaniment of other visual variables. Combining photography or illustration with a palette of complementary or contrasting hues can immediately evoke an emotional response. In some cases, the tones that are present within an image can take the place of background color or add emphasis to one area of a composition. In other instances, the tonal value of an image may recede so other elements like type and shape can stand out. Whether used as a focal point or in a supporting role, combining photography and illustration with color can produce evocative visual arrangements.

Images can be intense, intriguing, humorous, or surprising. Certain subjects are sure to draw a viewer's attention. One basic question when working with imagery is whether or not to use color or black-and-white photos or one-color illustrations. The answer should always be determined by the specifics of a project. In some cases, a black-and-white image will have a stronger impact than one that is reproduced in full color. On the other hand, even a small amount of color can add emphasis, evoke meaning, and reveal visual hierarchy. The addition of imagery can help to tell a story and can be used as a way to quickly convey information or to set a mood.

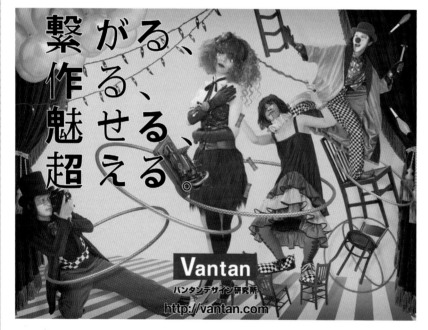

▲ Images of funky-looking students will attract potential applicants to the Vantan Design Institute, so the money spent on the photo shoot is sure to pay off. Design: Seitaro Yamazaki (Macla, Inc.), Tokyo

▲▲ A lighter value of the dominant orange tone sets the type apart from the vibrant blue and orange of the background image. Sampling a color from an image allows a photo to be prominent, while still being fully integrated into a composition. Design: José Manuel Morelos, Veracruz, Mexico

▲ Colored textures make this photo seem extraordinary and allow it to fit into an overall brand strategy. Design: Culture Advertising Design, St. Petersburg, Florida

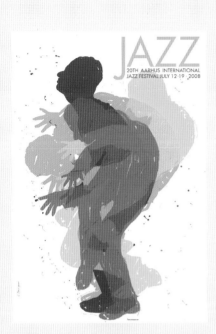

▲ Overlaying colors and layered imagery work together to show movement and suggest the idea of jazz, even before the reader gets a chance to read the text.
Design: Finn Nygaard, Fredensborg, Denmark

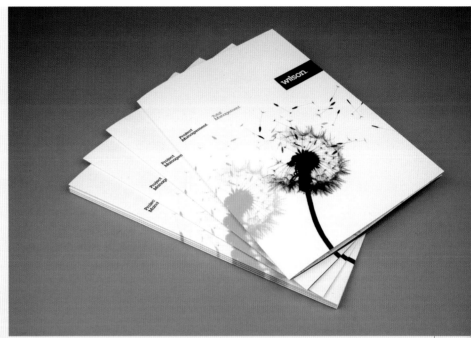

▲ A black-and-white photo is repeated as a halftone or monotone image, giving this report a refined appearance. Design: THERE, Surry Hill, Australia

▲ Imagery, both photographic and illustrative, is the primary communication element in this piece. The color is simply incorporated into the photograph. Design: 2FRESH, London, Istanbul, Paris

To ensure that a viewer's attention is focused on the correct text or part of a composition, the color relationships within a given image need to be balanced with the other visual elements. Overlays, monotones, duotones, and spot colors can give a designer greater control over how an image is perceived. Additionally, an image that already has strong color can be cropped or placed to have the maximum visual impact.

A good way to achieve successful color relationships within an image-based composition is to choose colors that contrast with other visual elements. Another trick is to identify subordinate and accent colors by sampling colors from within the image using the eye-dropper tool in your software program. The repetition of particular tones can make a composition feel unified and will usually result in a more harmonious color palette.

Speccing Imagery

Depending on the size and scope of a project, a designer may be able to pay for imagery. A large job will frequently include money to hire or work with a photographer. Unfortunately, photography budgets are often the first thing to be cut by cost-conscious clients. If that happens, finding the right images for a project will require a bit of detective work, making the most of a small budget, and choosing wisely.

Stock-photo companies such as iStock, Shutterstock, and Getty Images make a tremendous amount of visual material available online to designers at relatively reasonable rates. Images come in black and white and full color, and most sites include illustrations, textures, and video footage. Designers often cringe at the idea of using stock photos because they feel they can make their work seem contrived.

Fortunately, stock-image sites allow creative photographers and illustrators (including amateurs) to sell their work, and it is often possible to get a unique-looking image for as little as $5 to $10 (£ 3 to 6) depending on resolution and copyright permissions.

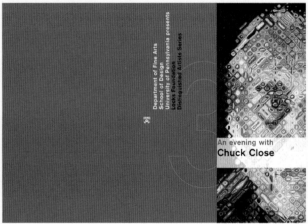

▲ Photos aren't the only way to incorporate imagery in design. In this case, a painting has been cropped as a way to visually advertise an event where the painter, Chuck Close, will be speaking. Design: Paone Design Associates, Philadelphia

◀ Cropping and tinting the photos makes the imagery seem like a part of the overall design but not the focal point. This means it is possible to use lower-quality photos and still produce high-quality design. Design: Alex Girard, Santa Barbara City College, Santa Barbara, California

Even without a photo budget, there are still ways to successfully incorporate imagery into a project. Taking your own digital photos is easy and immediate. Another way to find images is to search Flickr and other photo-sharing sites. Many people upload full-size, copyright-free images that can be downloaded directly from these sites. If the resolution of an image is too low online, one can email the person who took the picture and ask for a higher-quality version. They will often allow their image to be used for free as long as they receive credit.

▲ Redrawing an iconic image and combining it with type or other elements, such as line or shape, can add freshness to a well-known motif and is a low-cost way to include imagery in a composition. Design: Götz Gramlich, Heidelberg, Germany

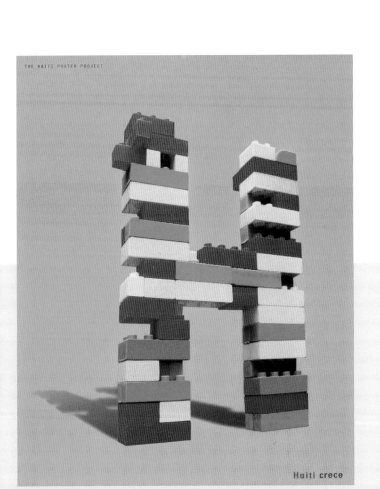

▲ When designing for a cause, one often needs to be creative to come up with solutions that won't cost a lot of money to produce. In this case, a structure made with LEGOs is a colorful reference to Haiti. Setting the photo on a yellow background makes the poster seem complete and intentional. Design: Juan Madriz, Edo Falcón, Venezuela

▲ The orange and green hues used as dominant colors for these book covers are very different, but the size of the books and the consistent treatment of type and image will allow viewers to recognize that they are part of a series. Design: Project Projects, New York City

When Image Is Illustration

Illustration is an excellent way to visually represent an idea, object, person, or place. Packaging, motion graphics, and scientific texts often use illustrations rather than photographs. When choosing an illustration, it is important to identify a visual style that complements the message, package, or design piece. Consider the budget and your own rendering skills. Determine whether you can create an appropriate illustration yourself. In some instances, it is possible to buy ready-made or stock illustration and alter it so that it seems unique to the project. This is a great way to achieve maximum impact with very little money.

The type of illustration that is being used, the context, and the intent of the finished product should determine how color is applied. Color should be considered from the start of the illustration process since it can change the entire mood of a project. If a freelance illustrator has been hired, it is important to discuss color in the initial project meeting or brief. When using stock illustration, there is no need to compromise. Try to choose an image that can be easily altered or customized.

An illustration can be as simple as line art or a drawing. In some cases, using images that are black or neutral in color may help create a solution that is visually sophisticated and very specific. Using a one-tone illustration allows color to be incorporated elsewhere within a composition and may also be easier to accurately reproduce in print or on packaging.

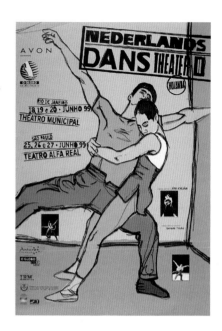

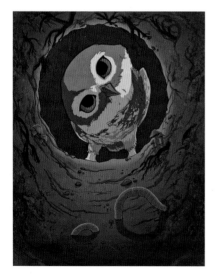

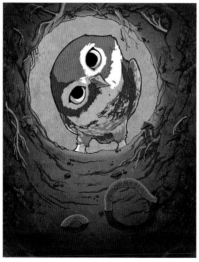

▲ Simple line art lends expressiveness to this composition. By using large fields of one hue at a time, the designer avoids complicating the composition unnecessarily, but the color still enhances the illustration. Design: Felipe Taborda, Rio de Janeiro, Brazil

◀ By changing the value of a color scheme, it is possible to radically alter how an image is perceived. The image on the left seems sinister, while the owl on the right appears merely curious. Design: Keri Dodge, New York City

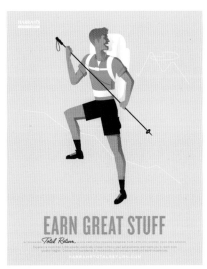

▲ Using illustration is a great way to give consistency to a series. A unified style, combined with different color schemes, makes these posters fun and unique. Design: Hatch Design, San Francisco

▶ An illustration can be powerful enough that it can stand on its own, visually. Here, the primary type treatment mimics the style of the illustration and the use of color differentiates space but doesn't overtake the image. Design: Ames Bros, Seattle

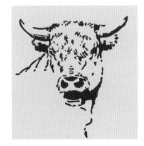

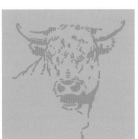

◀ Color always affects how an image is perceived. In this case, the illustrations of a bull seem to be quite different, depending on the background and fill colors used. The color choices used in the first example make the illustration seem fairly neutral, while in the second example, the background overpowers the image and makes it difficult to recognize. The contrast between the bright yellow and red makes the bull seem combative and a little mean in the final example.

Color As Provocateur

Color can inspire and tease. It can make us laugh and provoke a response. Throughout history, color has been used as provocateur, for political agitation, and as a tool for dissent. Revolutions, countries, and even political parties are often associated with particular hues. Yet the same color can have different meaning in different situations. Both Communism and the U.S. Republican, party are associated with the color red, even though these groups have radically different ideals and goals.

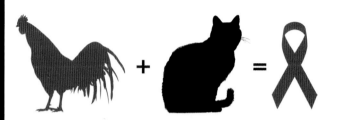

▲ When the imagery and message are this powerful the use of color should be minimal so as not to get in the way of the meaning. Design: Garth Walker, Durban, South Africa

Una vez derramado, se hace complicado.

▲ The contrast between the blue background and the black and white used in the foreground adds interest and makes the poster more noticeable. Design: Frank Guzman, Caracas, Venezuela

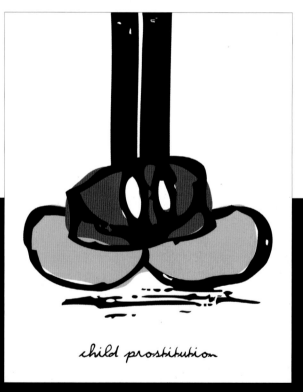

child prostitution

▲ This hard-hitting image doesn't need more than two colors. The style and color reference children's toys and clothing, but viewers will understand that the message is absolutely serious without reading the supporting text. Design: David Criado, La Paz, Bolivia

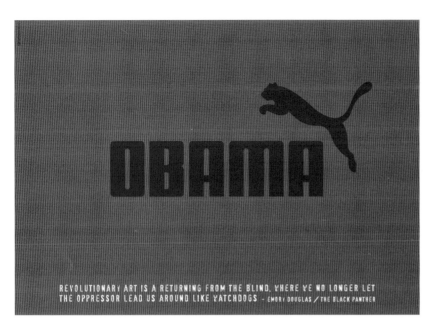

▲ Clever wordplay is the primary communication tool here, but setting the dark purple type against bright red further underscores the reference to the iconic sports brand Puma. Design: LSDspace, Madrid, Spain

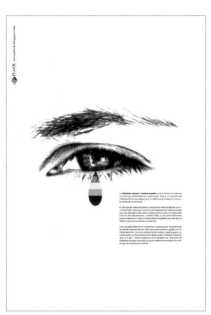

▲ The message of gay rights and violence against homosexuals is immediately understood because of the use of the "rainbow" in the shape of the tear. Color and image convey the message so well that it's possible to understand what is being communicated without reading the supporting text. Design: Ulises Ortiz, Mexico City

▲ Illustration is the primary communicative tool used in this poster, but adding colors that reference a map in the face further emphasizes this association. Setting the blue figure against the red background makes it stand out even more. Design: Juan Carlos Darias Corpas, Caracas, Venezuela

Since color takes on meaning through context and repeated use, certain movements may choose to adopt specific colors. The environmental movement has used "green" so often, that the color has become linguistic shorthand unto itself. In the 1960s the Black Panthers used an illustration of a panther with yellow eyes and connected it to the slogans "Panther Power" and "Freedom or Death." More recently, in 2004, the color orange took on new meaning when it was used by the opposition movement in Ukraine.

Nationwide protests and acts of civil disobedience were successful, new elections were called, and the results brought success to the short but triumphant "orange revolution."

Because color is such an excellent communicator of tone and meaning, it can be used to gather crowds, to help people identify with a cause, and even to poke fun at contemporary culture.

Type in Color

Whether a designer uses hand-drawn type, an expressive font, or one of the tried-and-true standards, how letterforms are perceived will be determined by the application or absence of color. The combination of type and color has the ability to produce successful visual design solutions, but it also comes with challenges. How one approaches color should differ depending on whether one is working on the layout of body text, a poster, or a large-scale project. Using color with body text can be tricky, and designers have to be careful not to apply tones with culturally specific associations to type-heavy design.

Color and Hierarchy

The relationships produced by combining color, intensity, and letterforms are nearly endless. To create successful design solutions, one has to understand how each element in a composition reacts to the others and how they come together to support the message that is being conveyed.

Great typography reveals a message and engages its audience. Clarity of form and proper hierarchy are key to a viewer's understanding of content. Color can be a primary factor in communicating relative importance. Along with scale and placement, the hues that one chooses to apply to type will allow certain words or phrases to stand out at the same time as duller or darker hues will make others recede. Color is made more effective by context, so when working with type, it is vital to choose hues that complement the tones present within imagery and other compositional components. A color palette should be able to accommodate all the typographic expressions that occur within a project. If it does not do so, it should be revised.

▲ Size, placement, and color work together to indicate hierarchy in a composition that is dominated by both type and image.
Design: Subcommunication, Montreal

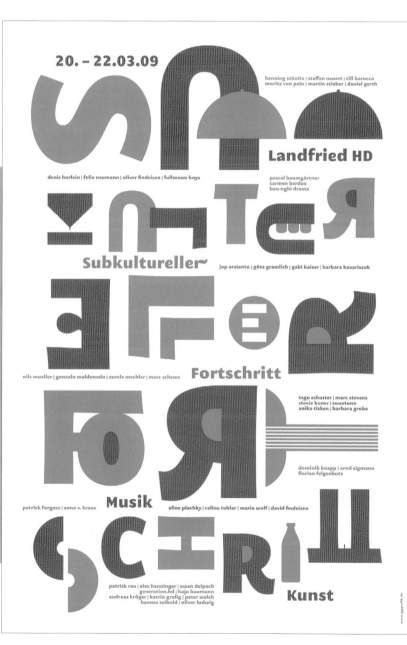

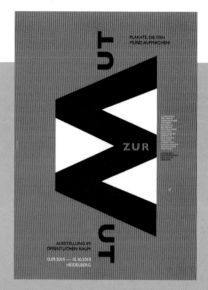

▲ Negative space and contrast are an excellent combination. Layers of contrasting tones suggest spatial depth and make the negative space engaging. Design: Gotz Gramlich, Heidelberg, Germany

◄ Letterforms are playfully arranged so that they create secondary shapes. Red and turquoise are not quite complements but are close enough that they visually vibrate off each other, adding interest and emphasizing both type and shape. Design: Götz Gramlich, Heidelberg, Germany

Specific Fonts

Certain fonts and typographic situations may lend themselves to different color palettes or relationships. The blocky letterforms of Rockwell or Univers 75 Black can easily take subtle tones or intense colors. However, more delicate expressions like Bodoni Book or Frutiger 45 Light have less visual weight and may require greater tonal contrast with the background and other typographic elements within the composition.

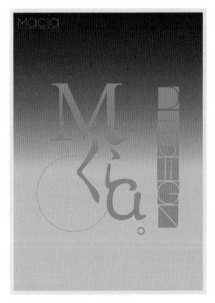

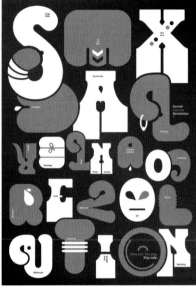

▲ The orange letterforms set against the green and brown background would be hard to see if they were smaller. However, their large scale and color mean that relatively few objects are needed to fill the space. Design: Seitaro Yamazaki (Macla, Inc.), Tokyo

▲ Customized letterforms are excellent for display type or to use as typographic expression. The text in this composition is readable because of its size and because the pink and white letters provide contrast against the brown background. Design: Götz Gramlich, Heidelberg, Germany

◄ In some cases, it may be appropriate to be more expressive with body text. The body copy for this catalog is in different colors according to the type of content and the language into which it is translated. Design: STUDIOKARGAH, Tehran, Iran

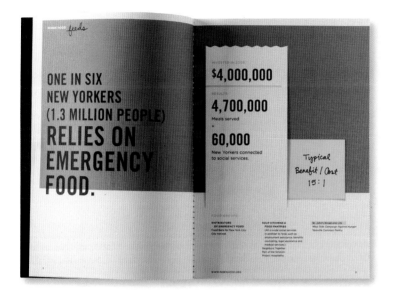

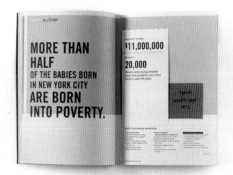

▲ Body text is most readable when it is on a white background, but in certain instances, using color behind type can help to create unity in a multipage project. In this case, color breaks up the space on the page and provides multiple areas where type can be placed. Design: Hatch Design, San Francisco

Body Text

Body text usually has to do the heavy lifting and communicate the meat of a message. The visual expression that is applied to body text should be in the service of overall readability and it should have enough contrast from the background that it is distinct. Placing body copy on a brightly colored background is a common technique used by some designers to make a page feel more "designed." Unfortunately, unless the background color is very light, is bright, or in some other way contrasts from the text, using color behind the type may make the content more difficult to read. Since a client's message will most often be communicated through text, it is imperative that the colors applied to the text don't get in the way of legibility.

▲ Here, color helps to differentiate columns of information and makes it easier to compare data. A unified color palette gives pages a consistent appearance while still accommodating variation. Design: Sebastian Guerrini, La Plata, Argentina

Don't Make Me Struggle

Viewers don't have the time or patience to struggle to read text. In certain instances, the relative hierarchy will require some parts of the text to be more noticeable. This doesn't mean the supporting text should be hard to read. Color only should be applied to text when it supports clarity and enhances visual engagement.

▶ A small amount of color can make an enormous difference when conveying visual hierarchy. Here, headlines stand out from the black text and white background, and bold treatment ensures that all the type is easy to read. Design: Project Projects, New York City

▲ In this poster for an exhibition of Brazilian digital pictorial fonts, most of the letterforms don't need to be read. This cross-cultural composition uses red as a specific reference to a Chinese paper-cutting technique.
Design: Brono Porto, Shanghai, China

▲ Even though the text is set right to left (as is customary in Hebrew), and it is red rather than black, it is easy to read and doesn't overwhelm the page.
Design: Shual Studio, Ramat-gan, Israel

▲ Even though many designers shy away from altering or stretching letterforms, these techniques can be appropriate for a poster that references movement. Creating solutions that echo the content is more important than sticking to the rules. Design: Billy Bacon, Rio de Janeiro, Brazil

▲ Wordplays and type compositions may break the rules of traditional typography, but this composition provides fresh perspective on using type in design. Design: 2FRESH, London, Istanbul, Paris

Exceptions to the Rule

There are exceptions to every rule. In some cases, a designer may use type in place of imagery or as texture. In such instances, the letterforms may be unreadable because of placement, scale, cropping, or their value. When type is used as texture, it is often best to use tonal variations or colors that make it less, rather than more, readable. If text doesn't need to be understood, it shouldn't give viewers the visual cues they need to read it.

Display Text

Display type is able to accommodate a greater variety of visual expression than body text because of its size. Adding color to large text can make it stand out even more. Color combined with scale acts like a visual exclamation point. When type is big, it is possible to apply a wide range of tones, textures, and unusual color relationships without detracting from legibility. On the other hand, some projects are better suited to a limited color palette, regardless of the size of the text. Using less color can be particularly effective for signage or when type is part of a wayfinding system.

▲ Texture and color give this logo a distressed look that will appeal to a younger, hipper crowd. Design: Ames Bros, Seattle

Display Text Adds Expression

LOREM IPSUM DOLOR SIT AMET

LOREM IPSUM DOLOR SIT AMET

Lorem Ipsum Dolor Sit Amet

Lorem Ipsum Dolor Sit Amet

Lorem Ipsum Dolor Sit Amet

LOREM IPSUM DOLOR SIT AMET

Lorem Ipsum Dolor Sit Amet

Lorem Ipsum Dolor Sit Amet

Sometimes, Less Is More

Letterforms are such strong visual elements that it is possible to create highly effective type-based design using limited color palettes. In some cases, a designer may use only black and white and incorporate color elements elsewhere in the composition. In other instances, it is possible to create simple and arresting typography by using values of only one color. The shapes and negative space suggested by typographic forms can be just as successful in black and white as they are in full color. And since printing one or two colors results in significant cost savings, this is a good option for low-budget jobs.

▼ The difference between positive and negative space, black and white, is highlighted by this artistic composition, which uses spots of color to create letterforms. Design: 2FRESH, London, Istanbul, Paris

▶ Expressive letterforms don't always need or benefit from the addition of color. Sometimes, it is enough to leave them black and let their form stand out. Design: Esteban Salgado, Quito, Ecuador

Chapter 3
Meaning and Emotion

Color and Psychology
Mood and Symbolism
Culture and Place
Aspects of Color
Color as Identifier

Color and Psychology

Color imparts meaning and evokes emotion. A person's response to color and tone can help determine how information is understood and can affect whether a consumer buys a product or uses a client's services. Scientists and psychologists have studied the relationship between people's conscious and subconscious perception of color and their associated meanings. Psychologists are particularly interested in the effect that colors have on the subconscious and on how these influences relate to people's understanding of the world around them.

The psychology of color has both theoretical and practical relevance for designers. In certain instances, scientists have found that the presence of particular hues has foreseeable effects on a subject. While not yet in widespread use, this kind of information might eventually allow designers to more effectively communicate with their audience. Designers who explore the effect that psychology has on our perception of color have the opportunity to make color choices that harness people's intentional and unintentional reactions to particular hues and combinations.

▲ Certain color combinations provoke immediate associations. The red, white, and blue combination used for this book cover plays on the reference of the American flag. Design: Ames Bros, Seattle

▲ Color is regularly used to persuade consumers to buy projects. The clothing items in this advertisement include color only sparingly, but the overall design is given atmosphere and made more seductive with the addition of violet highlights. Design: THERE, Surry Hill, Australia

Altering Behavior

That color has an impact on our conscious and subconscious mind is certain. What is less clear is how and when color is the primary motivator for altering behavior. In some cases, simple differences in color can lead to clear changes in behavior. For instance, scientists at the University of Rochester found that men were 10 percent to 20 percent more attracted to a woman wearing the color red than they were to her twin who was dressed in pastels. This preference continued on to monetary decisions with subjects reporting that they would be more likely to spend more money on the woman in the red dress. Color's effect on behavior isn't limited to attraction between the sexes. Police in Wales have painted a royal blue line on cell walls because there is some evidence that blue may encourage truthfulness.

If color really can change how we feel and possibly even cause us to behave in ways that we wouldn't otherwise, the repercussions for design and advertising are profound. Unfortunately, the reality isn't that simple. Scientists' understanding of how color can change and motivate our conscious or subconscious mind is still in its infancy. There is little doubt that color can be stimulating, relaxing, engaging, and even annoying, but translating that into a reliable recipe to sell products or make viewers uniformly pay attention to a client's message is a long way off.

The Prediction Problem

One of the biggest problems with using science to come up with a way to predictably affect viewers' behavior is that there are natural variations in people's perception. Another issue is that we often try to match our feelings to previously held expectations. These associations are based on prior experience and may be the result of age, gender, culture, or geography and they can get in the way when trying to isolate people's responses to color groupings. Generally, the more people have in common the easier it will be to forecast their reactions. If a designer can identify and anticipate the associations that people will have with a specific color, it is possible to create a palette that will produce the intended response.

◄ When combined with well-known shapes, the colors red, yellow, and black are guaranteed to reference signage. In this case, a viewer will know that there is a direct metaphor because of the color, the shape, and the exclamation point. Design: 2FRESH, London, Istanbul, Paris

Testing Responses

Focus groups can be a great way to test a color palette. If a client doesn't have the budget to pay for such a service, informally polling prospective audience members can be a good way to gauge whether a hue or combination of colors is producing the intended communicative results. Colors should be attractive and well balanced and should match the audience's expectations of them. If these criteria are not met, previous associations may overtake the message or alter its meaning. A designer will often have to go through several iterations of color groupings before finding one that is well suited to a project. Even after a general color palette has been determined, it may be necessary to create numerous variations of tone and intensity before finding the ideal combination.

▲ The combination of pink, turquoise, and brown complements the irreverence of the programming shown on the MTV network. Design: Ames Bros, Seattle

▶ A lot of thought is put into the color palette for the packaging of new products. This is particularly true for items like energy bars, which tend to be unexciting in their bare form and where the packaging is a consumer's first association with the product. Design: Hatch Design, San Francisco

Color Synesthesia

Synesthesia is a condition in which the stimulation of one sense leads to simultaneous involuntary experiences by one or more additional senses. In color synesthesia (color-graphemic synesthesia), letters or numbers are perceived as inherently being colored. The phenomenon of color synesthesia is an example of how variable color association can be. When designing something, it is always important to remember that an audience may either knowingly or unknowingly attribute meaning to hues. If synesthesia is at work, a reaction by one sense may even lead to a reaction and altered perceptional associations by another, thereby changing how a person reacts to the design.

▲ In the past, identity marks had to take production considerations into account. Embracing the advances in technology, this logo not only uses many colors but includes gradients and texture as well. Design: Culture Advertising Design, St. Petersburg, Florida

◄ It doesn't take a lot of color to convey mood and make a service attractive. Here, hints of warm magenta complement accent colors from the photos and add a bit of drama to an otherwise clean and spare design.
Design: 2FRESH, London, Istanbul, Paris

Mood and Symbolism

Color affects mood and behavior. It can change how we perceive a product or company and it can evoke atmosphere and convey symbolism. As much as 80 percent of our sensatory perception is determined by sight, so what we see is paramount to our understanding of the world around us. Given the importance of sight and the prevalence of color in the natural world, it is not surprising that humans have come to ascribe meaning to particular hues and color relationships.

▲ Bright red and army green are combined with texture and visual content to convey a slightly sinister mood.
Design: Ames Bros, Seattle

Researchers have found that the presence of color can positively affect our behavior. Dr. Carlo Raimudo, codirector of the School of Color and Design in Sydney, Australia, found that subjects in a colored room who were asked to perform basic tasks had lower levels of anxiety and lower heart rate and blood pressure than those who did the same tasks in a gray room. Dr. Raimudo suggests that adding color to our environment can enhance our ability to engage in problem-solving activities. Color's ability to improve productivity and mood may account for why a large number of design offices use color prominently in their décor.

If color can alter our ability to do simple tasks, it's not surprising that it can be used both to affect and to imply mood. In many cases, the mood or atmosphere suggested by color feeds into preexisting associations. The symbolism that is ascribed to colors may be more a product of continual reinforcement than it is an intrinsic attribute of a particular hue. Designers looking to successfully use color in projects should use pairings that convey the tone and feeling of the content before a viewer is able to comprehend the message. In this way, a color or combination of hues can foreshadow the theme or nature of the message.

▲ The combination of an illustration dominated by the color pink and the pink used for the text immediately conveys that the content on this page is fresh and young.
Design: Seitaro Yamazaki (Macla, Inc.), Tokyo

▲ Creating colored backgrounds is an excellent way to make a product seem special and unique. In these advertisements, alternating warm and cool color palettes are combined with imagery to convey mood and reference sophistication and quality. Design: The O Group, New York City

Practice Makes Perfect

Some people seem to have an innate sense of color. They are easily able to choose combinations that are harmonious. It is usually impossible to tell whether these people have a natural gift or whether greater interest has caused them to study color combinations more carefully. What is certain is that, for most people, creating successful color relationships is work and it is something that gets easier only after an ungodly amount of practice.

Inspiration is one of the greatest shortcuts to making better color choices. It may come at home, while driving to work, from historical references, or from pop-culture icons. But, in most cases, creating the appropriate color palette will still take multiple iterations and revisions.

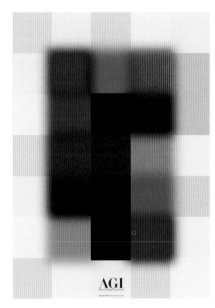

▲ This poster uses a dizzying number of colors, but the skillful placement of each in relation to the others makes the composition exciting rather than overwhelming or tedious.
Design: Katsui Design Office, Tokyo

▲ Playing off something as iconic as the American and French flag isn't for the faint of heart, but this solution plays off the content—the colors associated with the flag—and employs an original composition that transcends its references.
Design: Rudi Meyer, Yerres, France

Documenting Color Inspiration

If you are just starting out as a designer or feel that color remains a pesky problem in your professional practice, consider starting a sketchbook of inspiring color combinations. By training your eye to notice successful color relationships in both your personal and professional lives, it is possible to create a customized encyclopedia of color options that can be used as a resource when working on actual design projects.

This "inspiration book" should be highly portable. Begin by taking photos and cutting out images, textures, or text that catches your eye

with its use of color. You can use photographs, magazines, newspapers, brochures, or advertisements. Identify hues and tones that create harmonious or pleasing color palettes. Use colored pencils, Pantone swatches, or scanned-in pages and sample the colors in a program like Photoshop or Illustrator. Finally, paste your color combinations next to the original image reference and make a few notes on why this palette is successful and how it might be useful in a design problem. This inspiration book should be a work in progress and will be your own personal reference guide. It will help you

recognize successful color combinations faster and will become a place to go for inspiration when there are real-world projects to work on.

Note: There are many books on color out there that already do this for you. The benefit of doing it yourself is that it trains your eye to pick up pleasing color combinations on your own. Do this for a year, and you will be able to make better color choices faster.

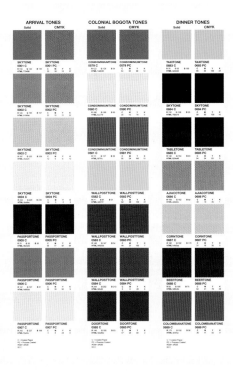

◀ Taking the idea of color inspiration one step further allows the designer to create a personalized swatch book of color options. In this case, each grouping is categorized by a place or facet of hues, but this system can be customized and used to create multiple individualized swatch books that could be paired with specific clients or for particular types of jobs. Design: Johanna Munoz, New York City (courtesy of Elizabeth De Luna)

▼ By putting two photos together it is possible to come up with unusual pairings that create unique and quirky color palettes. The photo of a dog's nose combined with a wall can make color groupings that could be used in a variety of contexts. While none of these pairings were created to be used on a specific project or job, they provide a treasure trove of color choices that can be called upon for all sorts of design outputs. Design: Johanna Munoz, New York City (Courtesy of Elizabeth De Luna)

Colectivo | Pandebono

Casa De La Cultura Walls

Tio Wilson | Taxi

Apartment Door | Goliath

Culture and Place

Culture and geographic location affect people's perception and understanding of color. Even our way of describing color is determined by where we come from. Terms for *red, green, yellow,* and *blue* are part of almost every language except Kekchi, a Mayan language spoken by indigenous people in Guatemala and Belize. Though the difference in how color is communicated verbally is less pronounced among most modern languages, there are still variations in the numbers of terms used to refer to different hues. For instance, fewer words are used to describe orange tones in English and Japanese than in German and French. In Japanese, there are several words for red and pink tones but there is none for violet.

How people perceive hues and the meanings that are ascribed to particular colors may be culturally significant but are not necessarily universal. If a design doesn't illicit the intended response from the audience, it may have to do with the color choices.

In Kekchi, only five terms are frequently used to describe colors: sacc (white), qkecc (black), ccan (yellow), cacc (red), and rax (green and blue).

▲ Color and the treatment of the imagery reference culturally specific historical style and give viewers cues to the content of this book.
Design: Javin Mo, Hong Kong

▲ Colors can have cultural association, but in most cases, text and/or imagery will be needed to confirm the correct interpretation of the colors used in a design.
Design: Adrián Fernández, Asturias, Spain

amnesty international Journalist Anna Politkovskaya 1958–2006

◄ Red is commonly associated with Communism and the Russian Federation, so it was a natural choice for the outline of the country that is placed over the heart of journalist Anna Politkovskaya, who is believed to have been assassinated for political reasons. Design: Suunnittelutoimisto BOTH, Helsinki, Finland

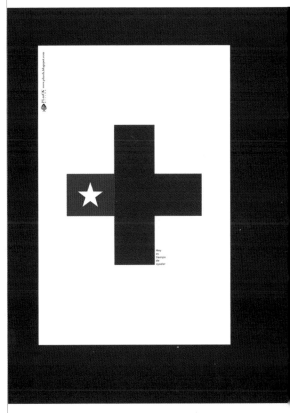

▲ Shape and color work together so that the text "Today it is time to help" simply underscores the visual message.
Design: Ulises Ortiz, Mexico City

Regional Specificities

In Western countries, white is often associated with weddings and with purity and innocence. On the other hand, in some Eastern cultures, white is a funereal color and is associated with death. In China, brides often wear red (the color of good luck), whereas in Thailand, almost any color other than black is acceptable. What is considered beautiful, festive, and appropriate changes depending on geography and culture. In some instances, color associations may be obvious, while in others, they can be subtle and can even lead to misunderstandings.

Designers are hired to create work that will appeal to the broadest possible audience but will still be sensitive to the individual characteristics that come with culture and place. For some projects, it is acceptable and even desirable to make work that relies on or takes advantage of cultural specificity. In such cases, an audience's understanding of color and its regional associations may act like a shortcut to the message or even refer to imbedded meaning. As long as both the designer and the client understand the particulars of the intended audience, combining ideas about color and culture can be a fun and exciting challenge.

▲ The lettering and signage for South Africa's Constitutional Court was based on extensive documentation of the site, which included prison graffiti and builders' markings. The designer then created a new font based on the place and those markings. Design: Garth Walker, Durban, South Africa

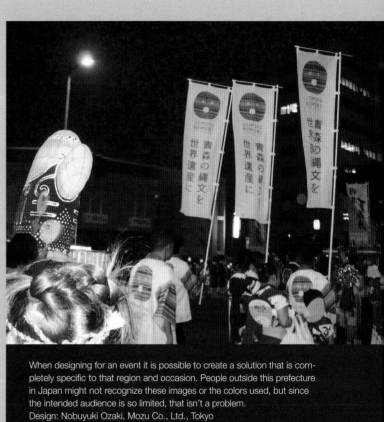

When designing for an event it is possible to create a solution that is completely specific to that region and occasion. People outside this prefecture in Japan might not recognize these images or the colors used, but since the intended audience is so limited, that isn't a problem.
Design: Nobuyuki Ozaki, Mozu Co., Ltd., Tokyo

Associated Meaning

When used correctly, cultural associations and meaning can help convey a message and put a viewer at ease. How people understand content is going to depend on their age, gender, wealth, marital status, and country of origin. These factors may alter whether one has negative or positive associations to the colors used in a composition. By knowing your audience and properly manipulating color relationships, it is possible to create visual compositions that are on target and will enhance meaning.

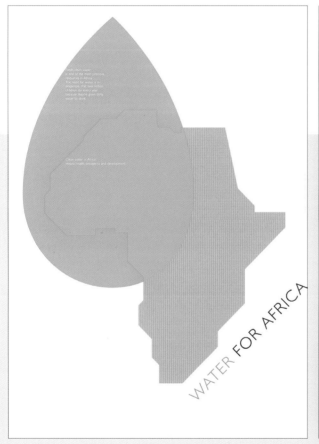

▲ The combination of color and image creates an immediate association that offers a shortcut to conveying the message in this poster.
Design: Paone Design Associates, Philadelphia

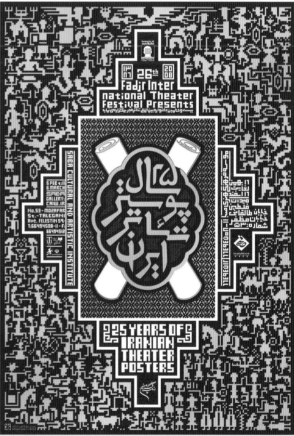

▲ The poster for this theater festival uses colors and textures that reference textile and tile design. Those associated meanings are targeted at a population that will be familiar with the motifs used in the composition.
Design: STUDIOKARGAH, Tehran, Iran

▲ The form of this sake container is so specific that it wouldn't be recognized in many parts of the world. However, in Japan, the object and its design lead to immediate recognition.
Design: Seitaro Yamazaki (Macla, Inc.), Tokyo

▶ Rich tones of red, yellow, and green are paired with a photograph. Color hints at the intended audience for this styling product, and image confirms it.
Design: Culture Advertising Design, St. Petersburg, Florida

◀ The pink and light colors used in this advertisement for Kotex are considered feminine colors, which works well for products that are aimed at women. Design: 2FRESH, London, Istanbul, Paris

Aspects of Color

Color combinations can be light and dark, hot or cold, pale or bright. The term *aspects of color* refers to hues or combinations that provoke a certain response or have predictable characteristics. The color palette that is appropriate for a job will always be specific to the content, the client, the context in which the work will be viewed, and the audience that the project intends to reach. But understanding the basic aspects of colors and their attributes can be a helpful starting point for designers who want to use successful color combinations to improve their work.

▲ The cool green makes these stamps look fresh and lively on any envelope.
Design: Suunnittelutoimisto BOTH, Helsinki, Finland

▲ Bright pink letters seem to be part of the image of smoke in this two-color composition. The photographic representation of smoke adds depth to the two-dimensional space.
Design: Timo Turner – Schmidt Thurner Von Keisenberg (STVK), Munich, Germany

◀ Here, the large yellow circle shows viewers where to look first, while the other brightly colored circles create an exciting compositional space. Design: Melchior Imboden, Buochs, Switzerland

Between 80 percent and 90 percent of color choices are based on rational decisions. The other 10 percent to 20 percent can be based on trial and error or inspiration. Choosing which aspects of color to use in a composition should be determined by considering what combination of hues would support the message.

◀ When combined with a few brighter accents, pastel colors can form the basis of a design that highlights content while still being interesting and dynamic. Design: Shual Studio, Ramat-gan, Israel

Vivid compositions are likely to attract a viewer's attention, but they may not be appropriate in all situations. The design of collateral material for a spa will rarely require a vivid or overly saturated palette. Similarly, intensely bright colors might not be appropriate for a promo for a television documentary about depression in children. Using color combinations that are too timid can be problematic as well. Designers should strike a balance between groupings that may seem brash and those that don't attract enough attention.

Color palettes that include light and dark hues have optimum contrast and are easiest to see. Hues that reflect light should be used alongside those that absorb it. Rarely can two or more colors that reflect light be used together successfully. For example, a palette that includes only bright orange and yellow tones is likely to seem overwhelming and even garish. On the other hand, using only hues that absorb color can lead to situations where there isn't enough contrast.

When pairing colors, it is useful to remember that some groupings can make content more or less legible. The least legible combinations are red on blue, orange on blue, yellow on orange, and green on orange. In these combinations, the colors seem to vibrate against each other, creating visual tension. Or, in the case of yellow on orange, there is often not enough contrast for the two colors to be clearly differentiated from each other.

Light Affects Color

It is always important to consider how and where the intended audience will view a design piece. Whether something will be seen in daylight or at night affects how color is perceived. Even small changes in indoor lighting conditions (such as whether overhead lights are cool or warm) will alter color. If hues are seen outdoors, their intensity is determined by whether they are in direct sunlight or in shade. In reality, design deliverables often exist in a variety of settings, but it is still important to consider light and how it will affect the color used in a composition.

▲ The light emanating from these colored disks of plastic underscores how much ambient or radiant light changes color and our perception of certain hues. Design: Answr Inc., Tokyo.

▲ Light and color combine to lure customers into this storefront. Color can be used subtlety or as an accent in a design solution that is dependent on light. Design: THERE, Surry Hill, Australia .

▲ When designing items that are part of an exhibit or display, it is important to take into account the lighting in the space. Whenever possible, try to work with the curator or building supervisor to position lights so that they enhance the color in the design and make the displays more accessible. Design: Project Projects, New York City

Warm and Cool Colors

Warm colors are based on red pigments or light and are considered to be active and dynamic, while cool colors are based on blue and are usually seen as calming and dependable. It is possible to change a color from warm to cool by adding red or blue to it. For instance, adding a bit of red to yellow will make a warm yellow, while adding blue to yellow will make a cool tone. How well secondary colors work within a composition will often depend on whether they are warm or cool and if they absorb or reflect light.

Warm colors seem to advance against cool colors, so a small amount of a warm color on a cool background is usually considered to be more pleasing visually than its opposite. A designer may choose to put a cool tone on a warm background to attract greater attention or to take advantage of the tension produced by that combination. Visual elements, which differ most from their background, will be more noticeable, so it is possible to use both warm and cool colors within the same composition.

▲ Using contrast to sell products is a skill. The bright blue applied to the labels of this chocolate makes the candies look even richer and more delicious. Design: Hatch Design, San Francisco.

An easy way to tell the difference between warm and cool tones is to compare different grays. A gray that includes red will appear quite different from one that uses blue or green as a base. Similarly, a gray tone that is just a percentage of black may look flat compared with one that includes some colored pigment.

▲ Colors appear to be warmer or cooler depending on the hues that they are near. Here, the red in the middle is warmer than the cooler tone to its right and left.

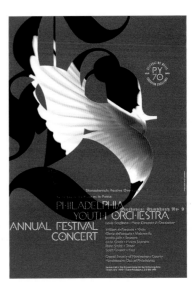

▲ The bright pink used in this poster for the Philadelphia Youth Orchestra is warm and lively. It provides a great background for the main illustrative element that is black and white. Design: Paone Design Associates, Philadelphia

Light colors are based on pale shades; at times, they may seem almost transparent. As colors get lighter, the contrast between hues decreases. Light shades make good accent and background colors. They also can balance brighter and more saturated shades within a composition.

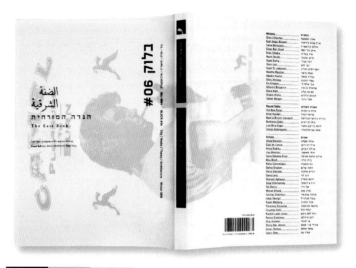

▲ Light colors can be particularly effective for a simple pared-down look when they are set against black, such as what was done on this book cover. Design: Shual Studio, Ramat-gan, Israel

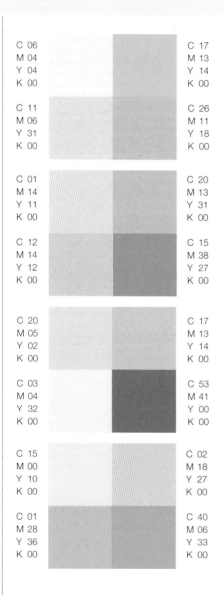

C 06 M 04 Y 04 K 00	C 17 M 13 Y 14 K 00
C 11 M 06 Y 31 K 00	C 26 M 11 Y 18 K 00
C 01 M 14 Y 11 K 00	C 20 M 13 Y 31 K 00
C 12 M 14 Y 12 K 00	C 15 M 38 Y 27 K 00
C 20 M 05 Y 02 K 00	C 17 M 13 Y 14 K 00
C 03 M 04 Y 32 K 00	C 53 M 41 Y 00 K 00
C 15 M 00 Y 10 K 00	C 02 M 18 Y 27 K 00
C 01 M 28 Y 36 K 00	C 40 M 06 Y 33 K 00

▲ White and light gray forms the basis of this website. The addition of a few brightly colored elements is unexpected and adds visual interest. Design: 2FRESH, London, Istanbul, Paris

Dark colors contain black. They can add drama and create mood. Dark colors can sometimes be used as neutrals within a composition. Like very light tones, colors with dark values have less contrast as they get darker. In order to achieve balance, it is often best to include a lighter or more saturated accent color in a palette that is dominated by darker tones.

C 80	
M 49	
Y 74	
K 50	

C 89	
M 91	
Y 41	
K 43	

C 94	
M 84	
Y 46	
K 53	

C 70	
M 63	
Y 00	
K 00	

C 52	C 64
M 52	M 50
Y 91	Y 99
K 37	K 49

C 68	C 45
M 68	M 75
Y 32	Y 83
K 13	K 65

C 59	C 43
M 54	M 84
Y 99	Y 66
K 50	K 59

C 76	C 75
M 69	M 67
Y 63	Y 67
K 83	K 90

C 55	
M 67	
Y 63	
K 54	

C 36	
M 54	
Y 63	
K 13	

C 73	
M 33	
Y 95	
K 20	

C 19	
M 48	
Y 76	
K 02	

▲ Even though most of the colors used in this poster are somewhat dark, a little bit of contrast on the left side of the composition makes the type stand out.
Design: Uwe Loesch, Mettmann, Germany

▲ Darker hues can be used as a background in packaging as well as print design. Accents of color and white type stand out on these semiopaque brown bottles. Design: The O Group, New York City

Bright colors are created using pure pigment. They are the purest form of a color without the addition of gray or black. Bright colors are excellent at attracting attention and are often used to advertise or highlight products. But too many bright colors in a single composition can be irritating to the eye and can actually decrease a viewer's ability to read or understand information.

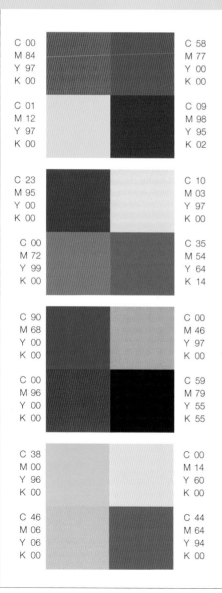

C 00	C 58
M 84	M 77
Y 97	Y 00
K 00	K 00

C 01	C 09
M 12	M 98
Y 97	Y 95
K 00	K 02

C 23	C 10
M 95	M 03
Y 00	Y 97
K 00	K 00

C 00	C 35
M 72	M 54
Y 99	Y 64
K 00	K 14

C 90	C 00
M 68	M 46
Y 00	Y 97
K 00	K 00

C 00	C 59
M 96	M 79
Y 00	Y 55
K 00	K 55

C 38	C 00
M 00	M 14
Y 96	Y 60
K 00	K 00

C 46	C 44
M 06	M 64
Y 06	Y 94
K 00	K 00

▲ It's hard to imagine using so many bright colors in one composition, but this design combines them so skillfully that the color ends up being the primary visual element in the poster.
Design: Katsui Design Office, Tokyo

▲ The accent of bright pink against a bronze background is sure to catch a viewer's attention. Here, the dominant bright color contrasts rather than mimics the product that is being sold.
Design: Maris Maris, New York City

Pale colors are hues that are made up of more than 65 percent white. They are often called pastels and may have specific cultural connotations related to them. They are often associated with newborns and weddings, and are generally considered to be feminine or childish. However, pastels can make excellent accent colors or even be used to highlight subtle color relationships.

earth

C 01
M 14
Y 11
K 00

C 28
M 12
Y 24
K 02

C 00
M 28
Y 02
K 00

C 22
M 00
Y 27
K 00

C 31
M 23
Y 03
K 00

C 15
M 06
Y 33
K 00

C 16
M 00
Y 00
K 10

C 60
M 54
Y 29
K 00

C 12
M 10
Y 16
K 00

C 20
M 27
Y 00
K 00

C 00
M 16
Y 49
K 00

C 02
M 22
Y 28
K 00

C 01
M 14
Y 11
K 00

C 36
M 49
Y 54
K 10

C 22
M 07
Y 07
K 00

C 37
M 12
Y 03
K 00

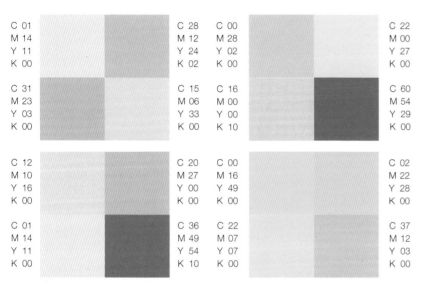

▲ Pale blues and greens are used for the leaf patterns that come together to create a snowflake design. This is a good marriage of color and content and proves that even a little color can have a lot of impact.
Design: Paone Design Associates, Philadelphia

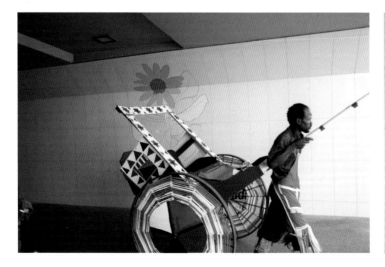

▲ When designing for permanent spaces, it is important to consider the context of how a space will be used. The designs on this stadium wall can be fairly subtle since there is likely plenty of visual activity from the people moving through the space. Design: Garth Walker, Durban, South Africa

Hot colors are based on warm tones that have red in them. When a color is defined as "hot," it is usually both warm and bright. Examples include bright orange, scarlet, and magenta. Hot colors make a statement. They can liven up a composition and are useful when promoting a product.

C 00	C 15
M 96	M 98
Y 00	Y 07
K 00	K 23

C 00	C 02
M 45	M 09
Y 95	Y 95
K 00	K 00

C 00	C 01
M 06	M 31
Y 99	Y 53
K 00	K 00

C 00	C 11
M 71	M 44
Y 95	Y 00
K 00	K 00

C 00	C 09
M 83	M 95
Y 95	Y 95
K 00	K 12

C 00	C 00
M 42	M 16
Y 55	Y 49
K 00	K 00

C 03	C 00
M 60	M 96
Y 00	Y 00
K 00	K 00

C 00	C 44
M 45	M 65
Y 95	Y 99
K 00	K 00

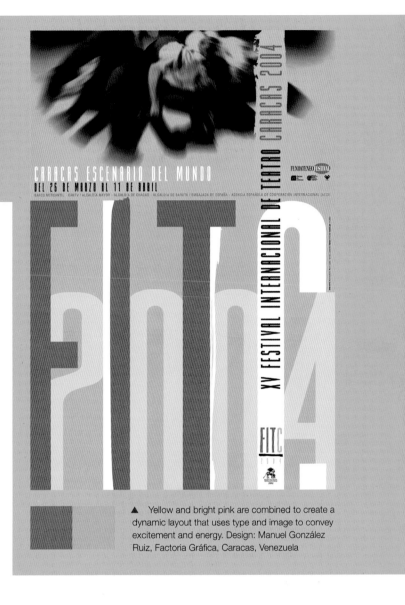

▲ Yellow and bright pink are combined to create a dynamic layout that uses type and image to convey excitement and energy. Design: Manuel González Ruiz, Factoria Gráfica, Caracas, Venezuela

▲ The hot pink in this logo is aimed at the female audience that the organization Jewish and Proud is targeting.
Design: Marc Rabinowitz, New York City

▲ Cool silver and blues make these vitamins seem both cutting edge and trustworthy. The triangles and different shades of blue are great to repurpose for advertisements aimed at health-conscious consumers. Design: Hatch Design, San Francisco

Cold colors are cool tones that are most often based on the primary color blue. They are an excellent choice when one needs color to recede into the background, to highlight a subtle message, or to communicate trust and conservativeness.

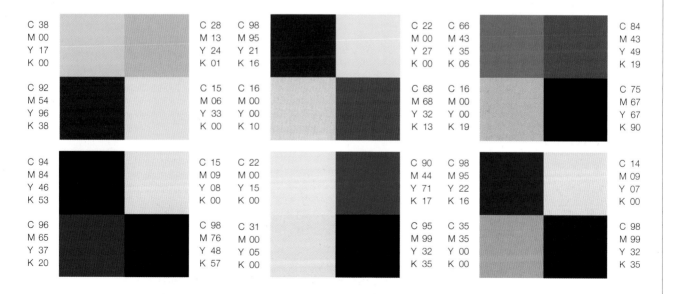

C 38 M 00 Y 17 K 00		C 28 M 13 Y 24 K 01	C 98 M 95 Y 21 K 16		C 22 M 00 Y 27 K 00	C 66 M 43 Y 35 K 06		C 84 M 43 Y 49 K 19
C 92 M 54 Y 96 K 38		C 15 M 06 Y 33 K 00	C 16 M 00 Y 00 K 10		C 68 M 68 Y 32 K 13	C 16 M 00 Y 00 K 19		C 75 M 67 Y 67 K 90
C 94 M 84 Y 46 K 53		C 15 M 09 Y 08 K 00	C 22 M 00 Y 15 K 00		C 90 M 44 Y 71 K 17	C 98 M 95 Y 22 K 16		C 14 M 09 Y 07 K 00
C 96 M 65 Y 37 K 20		C 98 M 76 Y 48 K 57	C 31 M 00 Y 05 K 00		C 95 M 99 Y 32 K 35	C 35 M 35 Y 00 K 00		C 98 M 99 Y 32 K 35

Neutrals are hues that have a large percentage of brown or gray, and they are one of the most overlooked and underutilized categories of color. If used correctly, they are great all-purpose tones. They can add emphasis and help a viewer navigate through content without the distraction of specific cultural connotations.

Color palettes dominated by these hues work well for projects that are aimed at a sophisticated audience or when the content should invoke calm and peaceful feelings. Neutral tones might be most appropriate when designing collateral for a coffee bar or when working with packaging that should showcase the product rather than its wrapping. Neutral tones are also highly effective as secondary colors or background tones within a palette that includes brighter or more intense hues.

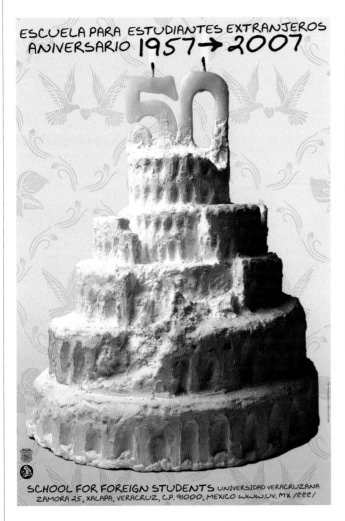

▲ Removing the color from a photograph or tinting an image so that it is reproduced in gray is a good way to achieve a unique solution and to work with simple compositional elements.
Design: Sebastian Guerrini, La Plata, Argentina

◀ The use of neutral colors in both the background and the foreground of the photograph creates an unusual solution that is successful without any bright tones.
Design: José Manuel Morelos, Veracruz, Mexico

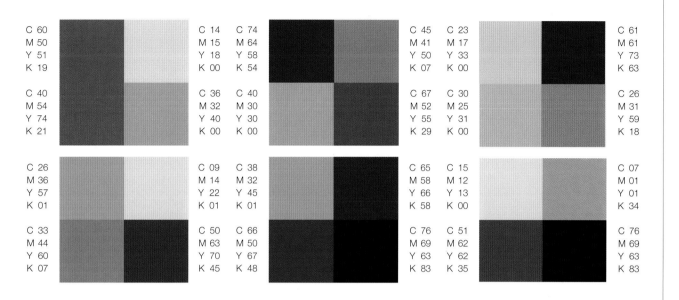

C 60 M 50 Y 51 K 19	C 14 M 15 Y 18 K 00 / C 74 M 64 Y 58 K 54	C 45 M 41 Y 50 K 07 / C 23 M 17 Y 33 K 00	C 61 M 61 Y 73 K 63
C 40 M 54 Y 74 K 21	C 36 M 32 Y 40 K 00 / C 40 M 30 Y 30 K 00	C 67 M 52 Y 55 K 29 / C 30 M 25 Y 31 K 00	C 26 M 31 Y 59 K 18
C 26 M 36 Y 57 K 01	C 09 M 14 Y 22 K 01 / C 38 M 32 Y 45 K 01	C 65 M 58 Y 66 K 58 / C 15 M 12 Y 13 K 00	C 07 M 01 Y 01 K 34
C 33 M 44 Y 60 K 07	C 50 M 63 Y 70 K 45 / C 66 M 50 Y 67 K 48	C 76 M 69 Y 63 K 83 / C 51 M 62 Y 62 K 35	C 76 M 69 Y 63 K 83

▲ The use of neutral hues carries over into every part of the design for the Fragner brand. The system allows for additional materials such as natural wood, and even pastries, to be part of the overall look and feel.
Design: Schmidt Thurner Von Keisenberg (STVK), Munich, Germany

Color as Identifier

Color is all-important when branding or creating a visual identity for a company. An identity mark or type treatment is likely to be what people remember most when they think of that business. The hues and tones used for a new logo can literally make or break the company that it is associated with.

When creating an identity mark or logo, color can help make a distinct visual impression. Companies that have used color successfully in branding are recognizable and memorable. When we think of Coca-Cola and Verizon, we immediately think red. Likewise, the color blue is associated with iconic brands like United Airlines and Walmart. Designers often choose primary colors for the visual mark of important brands. However, there are successful companies that use more unusual hues as part of their identity. The pink used by T-Mobile makes it stand out and suggests that the company is younger, hipper, and more nimble than its rivals Verizon and Sprint.

Conversely, banks and financial institutions usually employ more subdued color palettes because they want to show that they are safe, conservative, and trustworthy.

▲ Contemporary logos are often customized with colors or other visual texture. This set of museum logos is successful in red and gray but can also be dressed up by adding imagery into its signature letterform *O*. Design: Finn Nygaard, Fredensborg, Denmark

◀ The green in this logo makes the two shapes on the bottom seem like leaves or a part of a growing plant. This adds communicative value to the identity system.
Design: Sebastian Guerrini, La Plata, Argentina

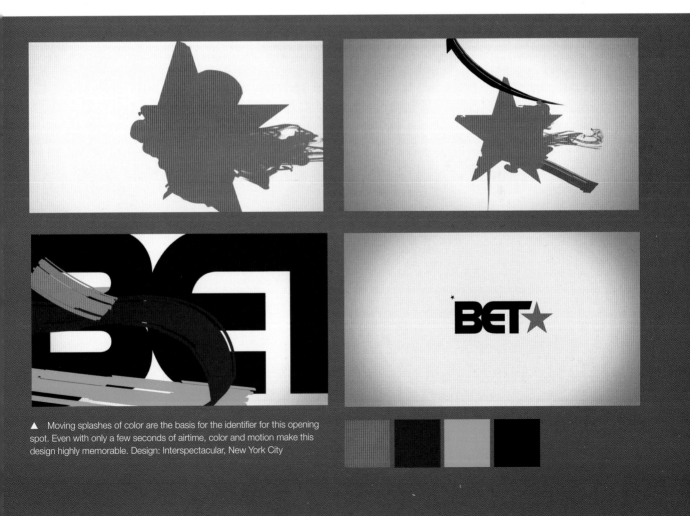

▲ Moving splashes of color are the basis for the identifier for this opening spot. Even with only a few seconds of airtime, color and motion make this design highly memorable. Design: Interspectacular, New York City

Targeting an Audience

Color choices should be made carefully and be based on the initial project brief, information about the client company and its competitors, and an analysis of what the client wants to convey to its customers or to the intended audience. Remember that people "feel" as well as see color, and will ascribe a set of values or attributes to a company based on how they understand color. A designer should identify the unique characteristics of the company and learn as much as possible about

what it sells or is trying to communicate to consumers. Find out everything you can about the target audience. Are they conservative or liberal? Young or old? Male or female? Will they be likely to take risks? Are they interested in trying new things, or do they just want to be reassured and made to feel at ease with the company? How these questions are answered will provide good indications about which colors might be appropriate to associate with the company or brand.

▲ In many cases, type is strong enough to be the sole visual presence of an organization. Consider giving clients a black-and-white version of the design that can be used where color isn't appropriate.
Design: 2FRESH, London, Istanbul, Paris

◄ Using overlays gives this logo the appearance of visual depth and works well with the organic theme.
Design: Sebastian Guerrini, La Plata, Argentina

EL RINCÓN ORGÁNICO

◀ Letting type and form be the primary focus of an identity is a good solution, especially if they are paired with a simple two-color palette. Design: Sebastian Guerrini, La Plata, Argentina

Variations of an identity can be used for different products. Humble packaging is made quirky and fun by the addition of customized labels that use diverse type treatments for the name of the company. Design: Subcommunication, Montreal

Color in Context

Specific research about context and culture will ensure that color doesn't get in the way of what the client wants to communicate. A client may address some of these issues in the project brief. If not, it is still the designer's job to take these variables into consideration. Find out whether the identity mark will have to work in an international arena or whether it will be confined to a local space or a particular country. Also consider whether there are cultural associations with the company, its products, or its services that customers should know about. If so, using colors that are linked to a certain region or place may help to increase sales for the client.

▲ The contrast between the orange and green differentiates the two parts of this logo and highlights the fact that the *c* has been given cat ears. This design has the benefit of working at any size in a variety of media. Design: LSDspace, Madrid, Spain

◀ A logo may be repeated on other collateral material so that a company can fully brand all aspects of its operations. In this case, the brightly colored design for Danish Air Transport is repeated on the planes and is incorporated into the flight attendants' outfits in addition to being used in more traditional situations. Design: Finn Nygaard, Fredensborg, Denmark

How successful the specific design of a logo or mark will be depends on whether it will be viewed in print, on TV, in advertising, on a physical product, or online. Find out where the mark will primarily be seen. This will help to isolate what colors will work for the client, and will also indicate how intense those hues should be and whether it is appropriate to combine more than one color to create a visual mark.

The designer should be able to create a virtual "picture" of a company, its values, its attributes, and the messages it sends to customers by answering the preceding questions. Similarly, an analysis of the audience or intended customer base will provide great data when choosing colors for an identity. It should be possible to make some basic color decisions based on the information that was found during the research phase of a project. Before presenting color choices to the client, test various color palettes on the identity mark or type treatment.

During client meetings, it is helpful to use data to back up the reasons why particular color palettes would be successful. In some cases, specialists working in marketing may already identify specific hues in the project brief. Regardless of whether research was conducted by the design team or with the help of marketing professionals, using data and fact finding will make it easier to convince a client that the best possible colors have been chosen for the solution.

▲ In most cases, identity systems try to be both visually simple and serious. However, there is always room for exceptions. These marks are evocative and visually interesting, even though they are visually complicated.
Design: Garth Walker, Durban, South Africa

Brand Guidelines

How a brand is seen across a variety of media and in different situations is too important to be left to chance. But just because one designer created the visual mark for a company, doesn't guarantee that the same person will be hired to design all the collateral or messaging. An in-house team may take over once the client has approved the final logo or identity mark. In some cases, a prestigious designer or design studio is hired to create a mark but another company or freelance designer will create the other collateral.

To ensure that a client's identity appears consistently in a wide range of media and over time, designers create branding guidelines. These guidelines act like an insurance policy and will guarantee that the PMS (Pantone Matching System) blue that was part of the initial design—and that the client approved—will be used in all future brand deliverables.

In the past, logos would often use only one or two colors, but as printing has become less expensive and more companies have a presence

online, on TV, or in some other form of digital media, identity marks that rely on three or more colors have become more common. A logo or typographic mark may be designed to work both in full color and in black and white. The greater the variations that occur with a mark, the more important it is to create clear and concise guidelines for how color, type, and spacing should appear. These guidelines are presented to the client at the end of the project and will be used long after the design of a mark or logo is completed.

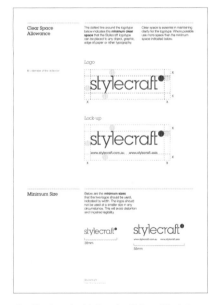

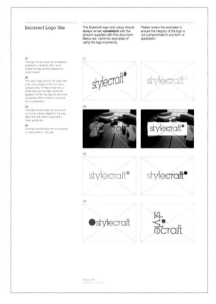

▲ The brand guidelines for Stylecraft include examples of the identity, how it should be spaced compared with other visual elements, a primary and secondary color palette, and examples of incorrect logo usage.
Design: THERE, Surry Hill, Australia

▲ Designer Bob Wilkinson had the challenge of incorporating the logo for UKAID into the identity treatment for the organization Esspin. In the brand guidelines, he provides a palette for full-color printing, for single-color printing, and for black and white. This ensures that the logo treatment will remain consistent, even though the production may change depending on how a project is produced.
Design: Bob Wilkinson, Abuja, Nigeria

Dos and Don'ts of Designing Identities

Do make an identity mark that is visually distinct.

Do use colors that will be visually successful across media.

Do create a logo that can be used as a one-color mark or as a multi-color mark.

Do deliver brand guidelines that specify specific PMS or CMYK colors and other attributes of the mark and how it should be used.

Don't design a mark that is too similar to the client's competition or too much like a well-known brand.

Don't make a mark that works only at one scale, that is, it is too visually complicated or uses too many distinct hues.

Don't use two or more colors for a logo if the mark will need to exist in many different situations (or create both one-color and full-color versions).

Chapter 4
Organizing with Color

Catching a Viewer's Attention

Series and Structure

Infographics

Catching a Viewer's Attention

Color is an excellent organizational tool and can be used as a way to differentiate content in packaging, print, and screen-based work. It can also be used to aid in wayfinding, information graphics, and multimedia design. Like semiotics, color gives cues that can stand in for a set of ideas, directions, or feelings. When working with multipage documents or on a project with many parts, tones and hues can be used to connect content or call out information. On the Web, color can give structure to text and image; in packaging, color provides a visual face to a product; and in motion, color can help to create reference for space and form.

▲ A relative balance has been achieved by repeating the circles behind the numbers that are the same color as the shapes at the top and bottom of this composition. Design: Billy Bacon, Rio de Janeiro, Brazil

◄ A hint of imagery and a lot of white space are set against irregular colored edges to give this poster a dramatic advantage.
Design: Finn Nygaard, Fredensborg, Denmark

FINN NYGAARD WITH FRIENDS
DET DANSKE KUNSTINDUSTRIMUSEUM
9. DECEMBER 2005 - 5. FEBRUAR 2006
BREDGADE 68 · DK KØBENHAVN K

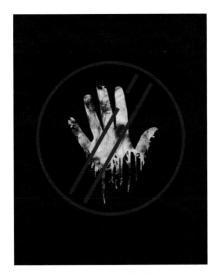

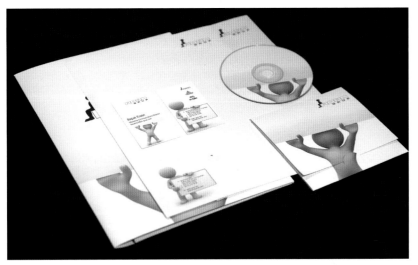

▲ The black and blue used in this poster reference oil and the ocean that it spilled into. The cold blue against the black communicates the seriousness of this topic. Design: Jesús Rodríguez, Doral, Florida

▲ Using a lighter value of a color, or gray, can give a smooth, sophisticated look. The "character" used in this design adds enough visual interest that a highly saturated color palette isn't needed. Design: 2FRESH, London, Istanbul, Paris

There is a common quip in the art world that suggests that if you can't make something big, you should "make it red." While that advice is overly simplistic, it is absolutely true that color has the benefit of being seen and identified from great distances. Think about how easy it, is to make out the logo of a well-known company like Target or McDonalds from hundreds of feet away, even while driving down a highway. The principle that color stands out against other compositional elements applies to posters, billboards, and even motion graphics.

Given the sensory overload that most viewers contend with, it's not surprising that color is very often the first thing we notice. After color, we tend to become aware of images and then of brand markers, and finally, we get around to focusing on the message the designer is trying to convey. For inexperienced designers, it might seem that the more color one uses, the more likely a viewer is to pay attention to the message being communicated. Unfortunately, it's not that easy. Too much color and/or color combinations that aren't harmonious may be unattractive and cause viewers to turn away. Also, overly complex or saturated color combinations are not appropriate for every message or in every situation.

▲ One way to make colors look like they belong together is to use hues of the same value, as was done for this cover design.
Design: Martijn Oostra, Amsterdam, Netherlands

It Gets Easier

Good color decisions are almost always the product of some degree of experimentation, but making the right choices gets easier with experience. In the beginning of one's career, it might be necessary to go through numerous variations in order to achieve a harmonious relationship, while an experienced designer will often arrive at a successful color palette more quickly.

▲ Dark colors work well when paired with brighter hues. The brown that is used for this brochure looks rich and velvety because it is set against bright orange.
Design: Willoughby Design Group, Kansas City, Missouri

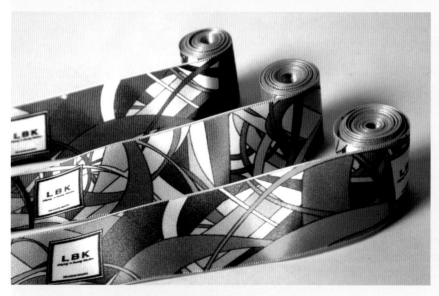

▲ Having colors that are in the same value range, but in different hues, clearly indicates that these ribbons are all produced for the same company. The consistent type treatment and pattern further underscore the similarity. Design: Seitaro Yamazaki (Macla, Inc.), Tokyo

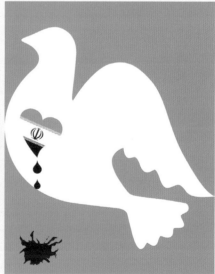

▲ The reference to the colors of a flag overpowers the more traditional associations that viewers may have with the combination of red and green.
Design: Marina Córdova Alvéstegui, La Paz, Bolivia

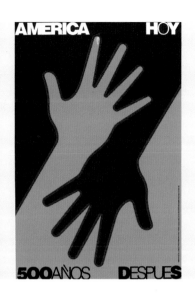

Tricks to Get It Right

The best way to achieve successful color combinations is to plan ahead. It is also important to make sure all decisions are based on the content of the message, the audience, and the context in which the project will be seen. Try to identify any cultural implications that a color might have ahead of time, and consider whether any implied meaning might get in the way of the message. An example of an imbedded color connection is the correlation between red and green and the Christmas holidays. In many parts of the world, it is difficult, but not impossible, to use red and green together without thinking of Christmas.

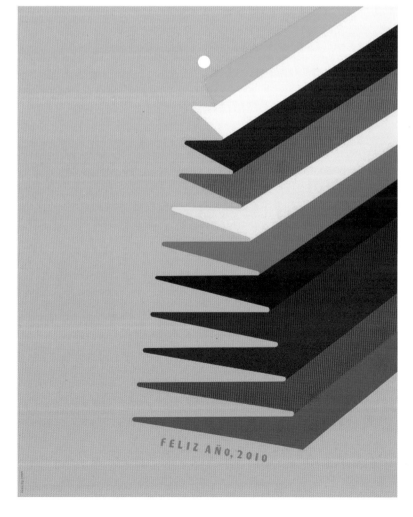

FELIZ AÑO, 2010

▲▲ The simplified drawing of arms and hands combined with bright colors emphasize the play between positive and negative space. Design: Santiago Pol, Caracas, Venezuela

▲ The combination of symbols is emphasized by the warm yellow and red tones used in this logo. Design: 2FRESH, London, Istanbul, Paris

▶ A vibrant rainbow of colors more reminiscent of the tropics than a winter holiday sets off the shape of the pine tree on this Christmas card. The unconventional palette brings interest and excitement to what can otherwise be an over-wrought subject.
Design: Juan Madriz, Edo Falcón, Venezuela

Tools for Selecting Colors

Numerous online tools to aid in color selection have been developed in recent years. Most of these sites are free, though some require users to create an account. Adobe Kuler (kuler.adobe.com) claims to be able to produce options that are applicable to any project and is a good source for designers looking to view a large variety of color palettes. The site uses crowd sourcing to identify and then rate various color combinations.

Color Scheme Designer is one of the most useful online resources available (colorschemedesigner.com). It allows users to decide which type of grouping they want to use e.g., mono, complementary, triadic, etc. The application then generates various palettes based on the base colors selected by the user. Color Scheme Designer shows colors in sample layouts and allows the user to apply more or less saturation. Users can pick which color system they want to use (RGB, Web safe, Pantone, etc.) and the application even provides groupings that will be visible to people who have color-impaired sight. The benefit of using online resources is that they make a tremendous amount of information available quickly. They are also excellent places to go for inspiration and can be particularly useful for young designers and/or to use in projects where a specific hue is required to be the base of a color scheme.

▲ White type stands out but doesn't compete with the layered color shapes in the background. Design: Juan Carlos Darias Corpas, Caracas, Venezuela

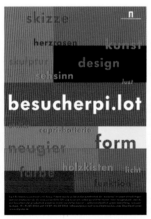
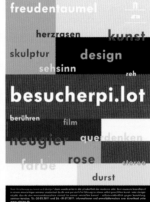
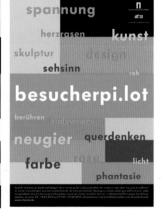

▲ Coming up with color palettes for four different yet related posters might seem daunting to an inexperienced designer. But this series shows what a difference color relationships can make and that it is even possible to use very different palettes within one series. Design: Schmidt Thurner Von Keisenberg (STVK), Munich, Germany

Communicating the Message

After you have attracted an audience, the design must be strong enough to hold the viewers' attention and convey the message. Color is an excellent tool to order and express information. Unfortunately, inappropriate color combinations may cause a viewer to lose interest before the message has been communicated. In such cases, color may be the downfall of an otherwise successful composition or communications program.

▶ These brightly colored banners are sure to be noticed. Using clean white text ensures that the text can be easily read, even from a distance. Design: Sebastian Guerrini, La Plata, Argentina

▼ Color and imagery help to draw a viewer's attention, but the separation of different sections allows the information to be communicated in a clear and concise manner. Design: Alex Girard, Santa Barbara City College, Santa Barbara, California

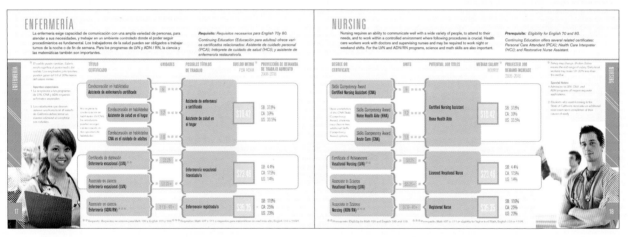

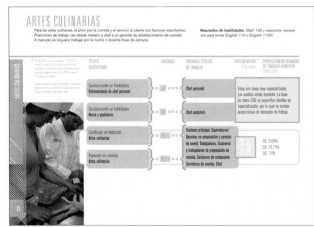

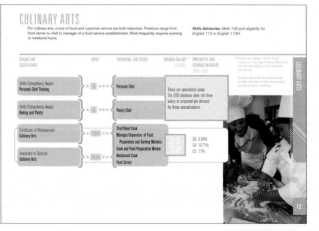

Over-the-Top Color Solutions

Combinations like black and yellow, neons, and other fully saturated colors provide a visual punch that can be startling and sometimes even unsettling. These hues can be garish and overly dramatic when communicating more complicated messages, but they are also immensely useful. Context is key. Ask whether the content being communicated can handle dramatic hues and if such color relationships are appropriate to the audiences being targeted. Experiment with various combinations before applying them to the content. Then visualize where the end result will be seen. In some instances, loud colors will blend into a busy environment and actually reduce the likelihood that a design solution will be noticed. However, if the output will be seen by itself or against a muted or neutral background, using a palette based on bright colors can make the difference between a mediocre design and an award-winning one.

▲ Pink, blue, yellow, and black are the only colors used here, but their strength gives this design the feeling of intensity that is intentional, even though it is extremely bright. Design: Valter Daniel Cacurri Oltra, Caracas, Venezuela

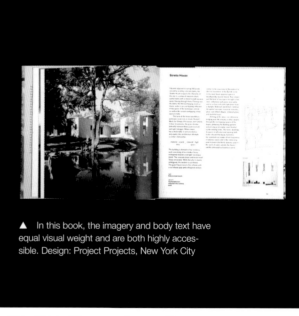

▲ In this book, the imagery and body text have equal visual weight and are both highly accessible. Design: Project Projects, New York City

◀ Red, white, and blue are usually reserved for flags and patriotic memorabilia, but this poster uses this well-known combination to its greatest advantage, creating a lively and ironic solution. Design: Dr. Alderete, Mexico City

Contrasting Colors

Contrasting colors are highly saturated, give a lively impression, and can be used to create expressive color palettes. These colors can get an audience's attention and hold it for long enough to convey the client's message. Contrast may come from hue or intensity. It may capitalize on the difference between light and dark, or it may be achieved by pairing colors that are complementary or opposite on the color wheel. Contrast can be particularly useful when certain elements need to stand out within a composition, so using a contrasting color as an accent within a palette can be especially effective.

▲ Imagery and other graphic elements add richness and interest to multipage projects. Design: Project Projects, New York City

Don't Let the Design Overtake Legibility

Most designers can appreciate a high degree of subtly, but to other viewers, slight differences can be confusing and may even go unnoticed. Gray text on a white background may seem refined, and choosing subtle hues in a narrow tonal range can be sophisticated in certain instances. Unfortunately, these decisions often don't work as well in real-life situations or for diverse audiences. This is particularly true when designing for an older audience or in situations where people may have difficulty seeing small type or noticing subtle tonal variations.

▶ The multicolored facets of these characters almost seem to vibrate against the white background, but when letterforms or other typographic characters are used as a design element, it is appropriate to be more expressive, especially if the supporting type is clear and easy to read. Design: Katsui Design Office, Tokyo

Getting Feedback

A good way to test how well color choices are communicating a client's message is to get feedback on preliminary design solutions. Asking other people's opinions provides valuable information and can help a designer avoid mistakes. Always put the successful communication of a client's message first and avoid making design that will be seen as successful only among other designers (unless, of course, designers are the target audience).

The best design uses formal elements such as image, color, shape, line, and type combined with variables such as scale, value, and placement to communicate to both visually educated and more general audiences. The MTA subway signage in New York City, designed by Massimo Vignelli, is lauded as a major achievement in the design world because of its smart simplicity. It uses a system based on color and easy-to-read Standard (and later Helvetica) text to communicate important transportation information. The same usefulness and clarity that Vignelli achieved in the MTA subway can be applied to almost any design project.

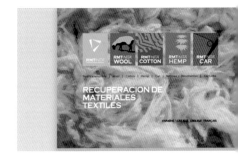

▲ The color on the home page of this website is derived mostly from imagery. This is a good solution when a company has great photography to represent what it does.
Design: Sebastian Guerrini, La Plata, Argentina

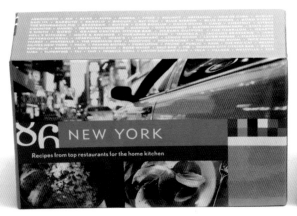

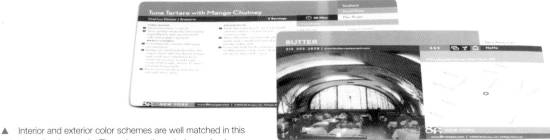

▲ Interior and exterior color schemes are well matched in this selection of recipe cards. The color on the exterior packaging makes the product seem fun and useful, and the layouts of the individual cards use color to highlight different aspects of each recipe. Design: The O Group, New York City

▲ A viewer will often have expectations of how a package for a certain product should be designed. In this case, choosing a color palette that didn't fit the jams might have caused confusion, so the designers mimicked the color of the product with the packaging. Design: Metalli Lindberg, Treviso, Italy

Questions to Evaluate Success

Assessing whether a project was successful is a necessary part of the design process. It ensures that mistakes are not repeated and can help a designer arrive at better solutions more quickly on future projects. Asking the following questions will help you evaluate how effectively color was used in a design project.

1. Did the design and color choices enhance the content?

2. Was it memorable?

3. Did it elicit the correct response (i.e., did the viewer watch the show, go to the event, buy the product, remember the brand, or take action)?

Series and Structure

In many instances, content benefits from being categorized or being broken down into multiple parts. In some cases, such as in the design of a magazine or a book series, an entire project or job may be dependent on the viewer understanding that there are many parts of a whole or that content is delivered in chunks according to a predetermined timeline. Using variations in hues or changing the dominant color in a palette can be an excellent way to differentiate serialized text or to show messages that are related. This technique allows a viewer to quickly distinguish between sections or parts.

▲ Individual items are given their own dominant tone while diverse repeated patterns allow the different items in the product line to be seen as a whole. Design: Maris Maris, New York City

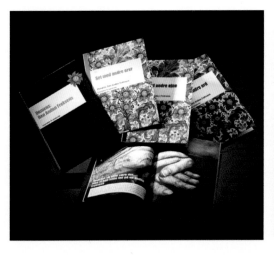

◀ Colored spines differentiate these publications, even when they are packaged together.

When taken out of their protective case, the colors are different but the consistent decorative pattern represents unity. Design: Finn Nygaard, Fredensborg, Denmark

◀ The full-color background on the right-hand page complements the tones present within the imagery on the facing page, and the color is used to set this text apart from other pages in the book. Design: Hatch Design, San Francisco

▼ The difference in color is enough to make each poster in this series seem individual, and the fact that all other compositional elements are consistent makes the posters similar enough to be easily identified as being part of a series. Design: Gerwin Schmidt – Schmidt Thurner Von Keisenberg (STVK), Munich, Germany

Difference and Similarity

Color can be an effective way to communicate difference and similarity. A small tab of color on the edge of a page can tell readers that they have come to a new section in a book, annual report, or website. If color is used as a coding device, it is essential that it be clear, simple, and consistent. Values that are too closely related may cause confusion. For instance, using a range of similar values of the same hue may communicate similarity rather than differences to some viewers. The greater the contrast between colors, the easier it will be for viewers to distinguish elements in a group. One way to code similarity in a series is to use several hues that have a similar value. This way, the color is unique and communicates difference, but the tonal value shows connection.

When working with a series or using color as a structuring tool, the first thing to do is to decide whether it is more appropriate to use color to differentiate items within the series or whether color will be a unifying element in the design. Both systems have their benefits. If a specific hue is used to show difference, it is often best that colors be designated for that purpose and be used as a dominant tone in any other component in the series. When using color to unify a document, it is often best to use it often and/or to repeat its location so that readers can *learn the system*.

Packaging and Display

Color influences our responses and is used by designers to help make products, packaging, and display systems more memorable. Particular hues are used to catch a consumer's eye and to entice them to buy a product or service. Color is almost always significant in the promotion of a product, and in the case of packaging, it can be a stand-in for the public face of a particular product or service. Specific tones or combinations are often associated with certain brands such as the green used on Sprite cans or the yellow and black used by Kodak. While it won't always be possible to achieve such immediate recognition, color will almost always help to attract buyers and differentiate one product from another.

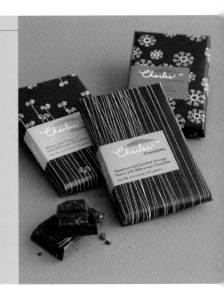

▲ A rich brown makes a great background for the brightly colored central part of the label, which is different for each flavor of chocolate. Design: Hatch Design, San Francisco

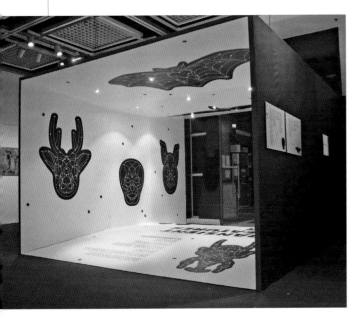

▲ Sometimes high-intensity colors will make a display more memorable, but in other cases, shape, space, light, and the use of a minimal palette will be just as effective. Here, the primary colors are black and white, but the space and shapes are so engaging that viewers are drawn into the display. Design: Javin Mo, Hong Kong

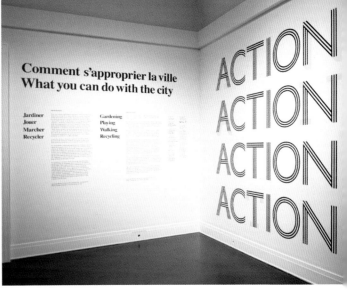

▲ The accents of bright yellow are a great addition to this customized lettering. The yellow attracts attention to the title of the exhibition but isn't used for the longer description where readability is important. Design: Project Projects, New York City

Packaging

Packaging jobs will require a designer to work with a wide range of materials, and production can be a real challenge. Fortunately, the benefits of well-designed packaging are tremendous. Rarely does one communicate so immediately with an audience. Packaging acts like three-dimensional advertising. In many cases, how effectively a product is packaged can have a direct impact on the sales of that product.

▲ Incorporating the color and texture of the package material into the design solution is a great way to save money and materials. The addition of a colorful label can be a good way to combine a two-color job with full-color printing. Design: Hatch Design, San Francisco

▲ When creating a system for an entire line of products, it will often be necessary to use a variety of materials and even some variation of style. In this case, colored labels are the dominant element for some products but not for others. This variation is appropriate because of how many different items are produced by the client. Design: Metalli Lindberg, Treviso, Italy

Choosing the Right Colors

Asking some simple questions can help to reveal how color can aid in packaging solutions. For instance, should color be used as a dominant element or merely as an accent? Does the product's package need to be visible, as is often the case with food and electronics, or does the packaging create a "second skin?"

If the client has specified materials, the designer should investigate how color works on each substrate.

Identifying whether the particular item is part of a larger series of similar products is also important. If many items will be seen or sold together, find out if each product should stand out from the others. How these questions are answered can directly affect a designer's color choices and can reveal whether it is appropriate to choose a color that is part of a spectrum that has previously been used by the company or whether it is appropriate to define a color palette from scratch.

▲ Packaging design often benefits from limited color palettes. These hair care products are designed with only two colors, but the difference in the shape and size of the containers sets each product apart. Design: Culture Advertising Design, St. Petersburg, Florida

▲ Each item in this series of products has been given its own color, but the use of similar pattern, placement, tints, and shades clearly identifies these sweets as belonging to a larger group. Design: Maris Maris, New York City

Matching Interior with Exterior

Exterior or secondary packaging needs to be complemented by interior packaging that looks good while the project is in use. For example, face cream usually comes in both primary and secondary packaging. The secondary packaging may entice a consumer to buy the product, but if the container that houses the cream is unattractive, it is unlikely that the consumer will purchase the product a second time.

▲ The exterior packaging of this wine gives visual hints to what's inside; similarly, the labeling on the bottles references the wine that they contain. Design: Timo Turner – Schmidt Thurner Von Keisenberg (STVK), Munich, Germany

Infographics

Concepts that rely on data and multifaceted ideas often benefit from visual design. Information graphics communicate complex information using text and imagery. Successful infographics act like a shortcut to convey content and to tell a story. They may include diagrams, graphs, charts, icons, and even illustrations. Color can make infographics more engaging, and it is used to communicate visual hierarchy in instances where there are multiple elements within a single composition. It is also an excellent tool to highlight the differences between components or ideas.

When working on information graphics, it is important to strike a balance between using color to attract a viewer's interest and using it to differentiate and clearly communicate the content. In most instances, each graphic or diagram will require its own color palette. Icons and simplified illustrations are often used in diagrams, maps, and charts. Sometimes, these elements will benefit from the addition of color, but in other instances, they may rely on shape and color will not be needed.

► The use of red on the right side and blue on the left side of this diagram works with the arrows to help emphasize the direction that blood moves in the circulatory system.
Design: Marc Rabinowitz, New York City

YOUR CIRCULATORY SYSTEM

Tips for Using Color in Infographics

1. Consider what role color can play in communicating the specific information or content.

2. Determine where the finished graphic will be placed and whether there will be competing hues or textures on the page or in the overall environment.

3. Develop a palette that enhances the text and/or visuals and helps to reveal information and/or shows the differences between parts or ideas.

◄ Mapmaking is one of the oldest and most common forms of infographics. In some cases, color will be a dominant aspect of mapmaking, but in this case, color choices are understated so that streets and landmarks are easier to pick out. Design: Shual Studio, Ramat-gan, Israel

◄ When giving visual representation to complex data, color is an excellent tool to help show different types or amounts of information. The book *Mapping Istanbul* uses color as a primary communicative element for diagrams, maps, pie charts, and other infographics.
Design: Project Projects, New York City

Layouts

When working with multipage documents, the most important thing a graphic designer can do is to motivate the viewer to turn the page. By successfully using color, designers can help to organize content, add drama, and create visually interesting layouts. Color may be used to make repeating elements such as headlines, rules, chapter starts, or page numbers stand out. It can also help to call out space on a page or highlight a specific section within a multipage document.

▲ In this layout, color is used to show different types of information and to help make the text columns more readable.
Design: Subcommunication, Montreal

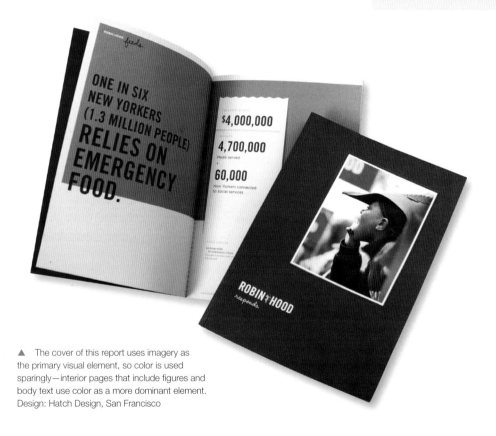

▲ The cover of this report uses imagery as the primary visual element, so color is used sparingly—interior pages that include figures and body text use color as a more dominant element.
Design: Hatch Design, San Francisco

Imagery in Layout

Using full-color imagery on a page is one way to catch and hold a viewer's attention. In some cases, imagery may provide all the color needed in a multipage document, but applying color to graphic elements such as rules, lines, and shapes will often produce even more exciting compositions. By repeating these elements at various points in a sequential document, the designer can give pages structure and allow content to be more easily absorbed by the reader.

◀ The imagery in this website provides more than enough color to catch a viewer's attention and sustain interest. Design: Project Projects, New York City

▼ Using overlapping shapes of bright orange and yellow creates a dynamic composition that works well for the start of a new section. Design: THERE, Surry Hill, Australia

▼ ▶ Color is used to highlight and distinguish sections of text in this book. Something as simple as adding color to a rule or the outline of a box can make text stand out on a page. Design: Finn Nygaard, Fredensborg, Denmark

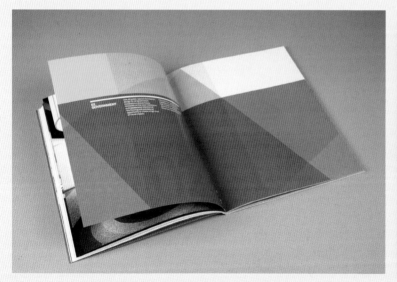

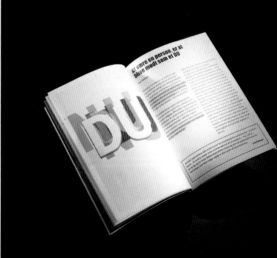

Background and Colored Type

Adding a background color to a page or coloring the type is an easy way to make a layout stand out. However, designers using these variables run the risk of making content difficult to understand and hard to read. Black text on a white background is the most legible because it has the most contrast. In specific cases, it may be appropriate to add a background color to a section of text, but it is still important to have a high degree of contrast between the type and the background color. Colored or gray text is most effective when it is used for sidebars, callouts, or headings, as display text, or for posters, signage, and other larger-scale projects. A combination of colored elements that support but don't overwhelm the body copy can help a viewer to notice different types of content.

Here, yellow text has been placed on a white background. In this case, there is simply not enough contrast for a viewer to read the text.

Here, yellow text has been placed on a white background. In this case, there is simply not enough contrast for a viewer to read the text.

▲ This series uses color and imagery to make a distinction between different books. The title and other text are either black or white, which gives consistency to the series regardless of the color behind the text. Design: Shual Studio, Ramat-gan, Israel

◀ This set of collateral material includes a lot of full-color imagery and textured components, but the black body text is elegant and simple.
Design: Garth Walker, Durban, South Africa

▲ If the viewer can pick and choose what part of text interests him and he doesn't need to read everything, using color for some of the body text can be a good technique to add interest to a layout.
Design: Seitaro Yamazaki (Macla, Inc.), Tokyo

◀ The color yellow provides consistency to this report, even though it is used as a flat color on some pages and as an overlay or accent on others.
Design: Sali Sasaki, New York City

Posters, billboards, and invitations are examples of design projects in which colored backgrounds can be appropriate and may even contribute to exciting and engaging visual communication.

Color in Motion and Media

Design for on-screen viewing is increasingly in demand. Working on-screen provides relief from traditional production concerns, but it also comes with its own set of challenges. Monitors and mobile devices may display colors differently. Increased user control has varying effects on how the color is actually seen by the user. For instance, if the brightness is turned down on a computer monitor, everything will appear dull.

When working with screen-based media, it is often necessary to design for the average viewer with the understanding that others may have slightly different experiences. Large corporations often require separate sites for different viewing devices. It is important to find out what percentage of a given audience is likely to be viewing a web page or other content on a handheld device rather than a regular monitor or TV screen. Find out whether a viewer's device will affect how color is seen or perceived at the beginning of a project and create a color palette that is designed to complement these conditions.

▼ Bright, vibrant colors and clean lines form the basis for this opener for the BET-TV network. Eye-catching design is particularly important in the busy visual environment that includes programming content and advertising. Design: Interspectacular, New York City

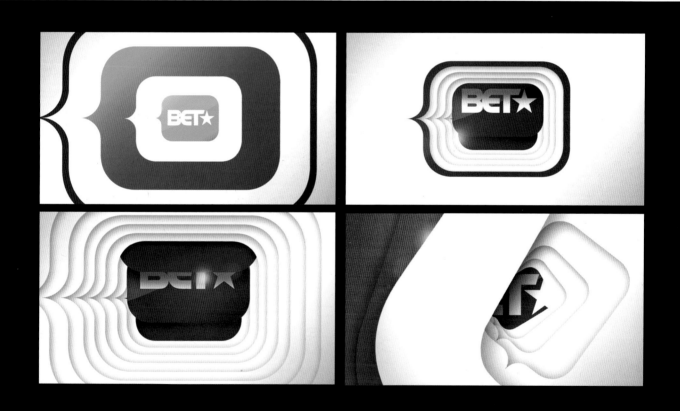

▲ Luscious photos of exotic landscapes provide the visual representation for Hillside Beach Club. The color used in the different menus and for the navigation picks up on the hues used in the logo and imagery.
Design: 2FRESH, London, Istanbul, Paris

Since a viewer has little or no tactile experience with on-screen design, color can create a sense of structure and a virtual depth of field. It is often combined with texture and imagery to further enhance what can otherwise be flat and somewhat static space. If it is used effectively, color will communicate content and ideas quickly without taxing a viewer's attention span.

▲ Color, imagery, and text all appear somewhat different on the Web. It is always important to test a website and find out how viewers perceive color before going live.
Design: THERE, Surry Hill, Australia

▲ This unique gridded navigation is a simple white overlay on a full-color image. When the goal is to show the product (in this case, buildings) using a neutral color palette for the text and background is an effective way to communicate online. Design: Project Projects, New York City

On the Web, color is often used to make a company or service seem distinct and to make a site stand out. Color can also support navigation structures and help make viewing faster and easier. When creating screen-based output, always test the design online or on the device where users will view content. Use a color palette that is the same or complements a client's overall branding strategy. If a client has

both an on-screen and a print presence, the colors used in all iterations of the design outputs should be consistent and recognizable. Hues or values of a color can be used to differentiate pages or sections within a larger website. In other instances, consistency will be more important and a site may require a very limited number of colors and/or the use of only one color.

▲ Gray, white, and light blue make up the primary color palette for this website. Hierarchy is conveyed with placement and by using existing conventions of left-side navigation rather than with color. Design: The O Group, New York City

Color in Motion Graphics

Motion graphics use movement, implied space, color, and other visual elements to attract attention and communicate a message. Time and movement allow the designer to create dynamic visual expressions. Since many motion pieces last seconds rather than minutes, the designer has to quickly catch and hold a viewer's attention. In motion graphics, color is used as a visual shortcut and as a way to tell part of a story more quickly. Patterns and the repetition of colors provide predictability and can help keep an audience interested while specific tones may reference content or imply mood/atmosphere.

Designers working in motion may use type, vector imagery, or live-action footage to communicate a client's message. When working with stills or live-action footage, color can be used to connect otherwise unrelated elements or enhance poor-quality footage. When used with shape and line, color can suggest depth and three-dimensional space on screen. Combining colors and overlays in specific areas can give a design the appearance of virtual space and depth. This technique is especially effective to use with vector graphics and text but can also be applied to live-action footage in specific instances.

▲ A limited palette of cool green and blue with textural accents is used for this *New York Times Knowledge Network* promo. The design is particularly successful because it incorporates elements with a hand-done and organic look. Design: Interspectacular, New York City

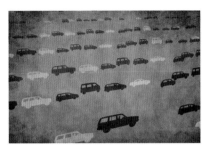

reducing **energy usage** =
removing **6 million cars**
from the road

if she can do it,
so can you.

join
the
fight.

▲ Multiple shades of the same blue give this design consistency. It seems more "hand-done" than computer generated because of the addition of texture. Design: Liz De Luna, New York City

Goals for Motion and Media

1. Reduce the time it takes for viewers to comprehend information.

2. If there is text, make it readab

3. Use hierarchy to reveal relative importance.

4. Create a color palette that is specific to on-screen viewing.

5. Use hues and tones that enhance the message.

6. Use repeated elements or colo to create a unified look and fe

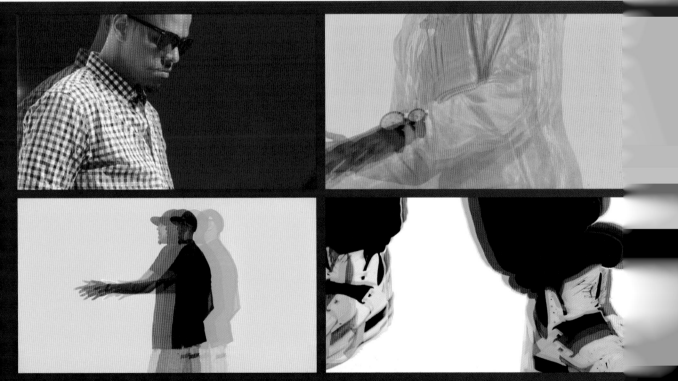

▲ By overlaying and repeating different screens of color, this music video seems polished and exciting. This is a great technique to use on low-budget projects where the video footage doesn't include a lot of variation. Design: Oska Ho, New York City

Chapter 5
Rules for Working with Color

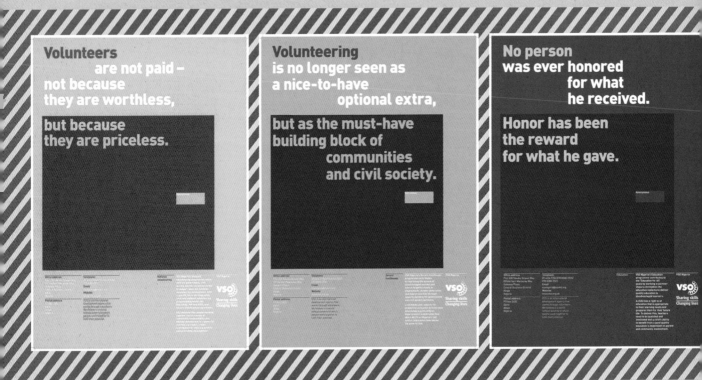

▲ A palette that uses similar values of a single color ties this series of posters together. Shape and the placement of type further reinforce that the posters are part of a series. Design: Bob Wilkinson, Abuja, Nigeria

Color Quick Start

Experimentation will always be part of the design process, but many designers find that there are practical and creative benefits to working with structures and known models. Defining a working process and following some basic guidelines for when and how to use color in design projects can save time and make color selection easier.

The following set of rules provides a useful structure to begin selecting the appropriate hues for a project. The more experienced one becomes, the easier it will be to successfully choose and use color. Eventually, a designer should be able to develop a personalized working process that can be used for any project that requires color choices.

Ten Rules
for Working with Color

1. Work from goals.

Ask what the project needs to convey, including information, message, advertisement, persuasion, and mood.

Consider where the end product will be seen, in what media and/or context the project will be produced, and who the audience is.

2. Apply color theory and review existing knowledge about color.

Decide whether it is appropriate for the design to be bright, bold, or subdued.

Determine the attributes of the message and whether there are colors that are more or less suited for the content that is being communicated.

3. Make choices for a reason.

Identify colors with specific attributes.

Consider cultural connotations and regional specifics.

▼ Color choices should occur for a reason. Repeating the red and cream colors allows this composition to be unified, while breaking up space with black frames references the story. Design: Rubén Moreno, Caracas, Venezuela

▲ Color is an excellent tool to organize and structure content.
This piece uses color to tie the various pieces of collateral together.
Design: THERE, Surry Hill, Australia

4. Choose color and make it count.

Pick dominant, subdominant, and accent colors.

Explore variations of shades and tints.

Try replaying one or more colors with its complement.

Consider colors that absorb rather than reflect light.

Limit the number of colors used in a palette.

Explore neutrals.

5. Be decisive.

Consider adding texture or image.

Don't forget about white space.

6. Test on content.

Let the content take the lead.

Make it different.

Make it clear/readable/ understandable.

Use organizing structures.

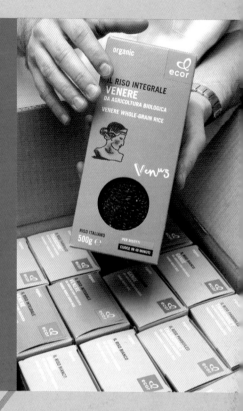

▲ In packaging, it is often necessary to let the content take the lead. Here, the product shows through the packaging and the designers have picked up the color of the rice for the cardboard box. Design: Metalli Lindberg, Treviso, Italy

7. Assess.

Consider whether the color choices enhance or detract from the content, and determine if it will appeal to the intended audience.

8. Adjust if needed.

Revision is a vital part of the design process. Creating multiple iterations of a project almost always produces better results.

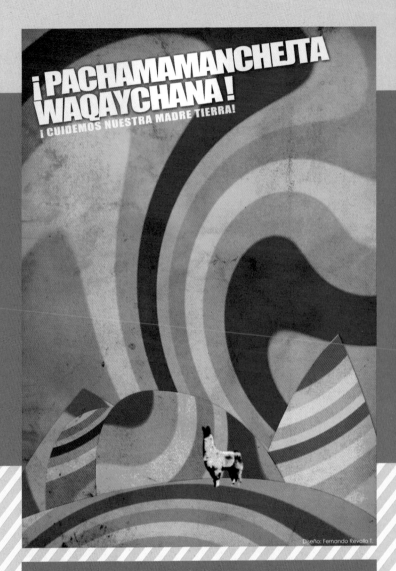

▲ This kaleidoscope of colors is effective in this design. Design: Fernando Revollo, Cochabamba, Bolivia

9. Produce using intended media.

Print design: Consider paper choices (coated versus uncoated, etc.), inks, varnishes, aqueous coatings, and finishing (binding, etc.).

Environmental design: Consider material substrates and color coverage and appearance, wear and tear and its effect on the finish, and project-specific production.

Digital output: Consider on-screen color appearance, ability of devices to accurately reproduce colors, and variations in users' devices.

10. Keep a record of successes and failures.

This is a great way to keep track of what works and what doesn't.

Color palettes that don't work for one job might be appropriate for another.

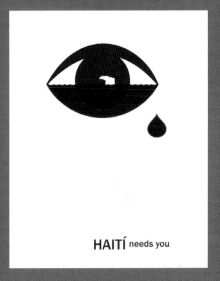

▲ This poster uses color to emphasize the message and to make the simple shapes stand out. Viewers know exactly where to look because the white background allows a few visual elements to stand out. Design: Arturo Botello Álvarez, Mexico

Real-Life Exceptions

Sometimes, you want to follow the rules, and sometimes you don't. Understanding the basics of color theory and knowing how certain hues relate to each other is indispensable, but great design can be produced with an "anything goes" attitude as well. There are exceptions to any set of rules. The "dos and don'ts" listed earlier are useful as a guide, but there may be situations where the best visual solution for a project flies in the face of everything that a designer has been taught or done before. Sometimes, unusual or risky color choices will help content to stand out or will be appropriate for a specific message or job. Being bold and taking chances can produce unusual and exciting design, and if a designer has the time to do so, testing a palette that breaks the rules can be well worth the time.

▲ The backgrounds for these designs are colorfully chaotic and fit well with content about "digital hallucination." The designer added white bars below the body text to keep it readable in areas where a simple overlay would have make the type hard to see.
Design: Martijin Oostra, Amsterdam, Netherlands

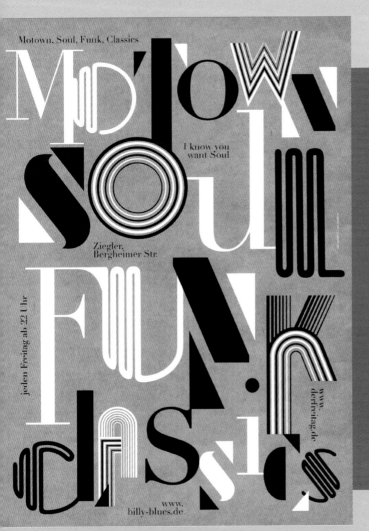

▲ Using layered type and texture inside other letterforms would be a no-no in most situations, but the size of the individual letters and the dark gray top layer produce a readable and unique design. Design: Götz Gramlich, Heidelberg, Germany

◄ The shapes created by this lively type-based composition are so interesting that a relatively limited color palette can be successful. The addition of a slightly textured background gives the piece the illusion of depth.
Design: Götz Gramlich, Heidelberg, Germany

▲ Showing how color will work in several design deliverables is a good way to help a client understand why certain color choices are appropriate for a project. In this case, the use of limited color is an excellent way to make the shape and type stand out. Design: Subcommunication, Montreal

Strategies for Working with Clients

Effectively communicating color choices with clients can make the difference between winning a pitch and getting a project approved or being sent back to the drawing board. Not all clients are visual learners, nor have they been trained to ignore the subjective nature of color the way designers have.

Presenting a clear rationale for why a palette or single hue will be successful usually provides the best chance of getting a color palette approved. Rather than simply presenting the client with a solution, explain how the colors in question support the message and fit with the overall brand strategy. Highlight the research that led you to conclude that these hues are most suited for the project and compare them to your client's competition. Color can have specific connotations for a viewer. By knowing what those might be ahead of time, it is possible to exploit associations when appropriate or minimize them if needed. Be sensitive to cultural considerations and explain what these are to the client.

The most important thing to remember is that almost everyone has an opinion about color. Clients are no different. It is up to the designer to use their expertise and to show how color can be tied to content to create effective communications strategies.

▼ This high-contrast black-and-yellow color palette is sure to grab viewer's attention and is a good fit for a hard hitting article about the NFL. Design: Lily Chow, New York

Contributors:

2FRESH
London, Istanbul, Paris; www.2fresh.com
Can Burak Bizer canburak@2fresh.com
36, 46, 56, 61, 73, 75, 79, 81, 91, 96,
106, 115, 117, 137

Adrián Fernández González
Asturias, Spain
35, 86

Alex Girard
Santa Barbara, California
www.ajgportfolio.com
alexgirard@gmail.com
18, 53, 62, 119

Ames Bros
Seattle; amesbros.com
barry ament barry@amesbros.com
51, 59, 65, 74, 78, 80, 82

Answr Inc.
Tokyo; www.answr.jp
Urara Ito itourara@answr.jp
11, 42, 94

Antonio Perez Gonzalez Ñiko
Xalapa, Mexico; www.soytimido.blogspot.com
soytimido@gmail.com
13

Arturo Botello Álvarez
Mexico; www.botarez.com.mx
botarez@hotmail.com
151

Billy Bacon
Rio de Janeiro, Brazil
www.bolddesign.com.br
billybacom@bold.net.br
73, 114

Bob Wilkinson
Abuja, Nigeria
(All work reproduced with kind permission
of Mott MacDonald and DFID)
11, 34, 111, 144

Brono Porto
Shanghai, China; blog.brunoporto.com/
design@bronoporto.com
72

Bruce Ian Meader
Rochester, New York
15, 17, 18, 19, 20, 21

Cheah Wei Chun
Clanhouse, Singapore
www.clanhouseonline.com
cheahweichun@gmail.com
43

Culture Advertising Design
St. Petersburg, Florida; www.culture-ad.com
Craig Brimm craig@culture-ad.com
60, 81, 91, 128

David Criado
La Paz, Bolivia; www.davidcriado.com
davidcriado@gmail.com
66

David Frisco
New York City; www.davidfrisco.com
david@davidfrisco.com
34

Diego Giovanni Bermúdez Aguirre
Valle, Colombia
diegogiovannibermudezaguirre.blogspot.com
dgbermudez@javerianacali.edu.co
12

Domingo Villalba and Yessica Silvio
Caracas, Venezuela
29, 35

Dr. Alderete
Mexico City; www.jorgealderete.com
contacto@jorgealderete.com
120

Esteban Salgado
Quito, Ecuador; www.estebansalgado.com
tiporight@gmail.com
75

Felipe Taborda
Rio de Janeiro, Brazil
64

Fernando Revollo
Cochabamba, Bolivia
13, 150

Finn Nygaard
Fredensborg, Denmark; www.FinnNygaard.com
fn@finnnygaard.com
57, 61, 104, 108, 114, 124, 133

Frank Guzman
Caracas, Venezuela
66

Garth Walker
Durban, South Africa
www.misterwalkerdesign.com
garth@misterwalkerdesign.com
36, 66, 88, 99, 109, 135

Hatch Design
San Francisco; www.hatchsf.com
Nate Luetkehans nate@hatchsf.com
65, 71, 80, 95, 101, 125, 126, 127, 132

Horacio Guia
Caracas, Venezuela
29

Interspectacular
New York City; interspectacular.com
Luis luis@interspectacular.com
105, 136, 137, 140

Javin Mo
Hong Kong; www.milkxhake.org
javin@milkxhake.org
86, 126

Jesús Rodríguez
Doral, Florida
115

Johanna Munoz
New York City; johannamunoz@hotmail.com
johannamunoz@hotmail.com
85

José Manuel Morelos
Veracruz, Mexico
60, 102

Juan Carlos Darias Corpas
Caracas, Venezuela; www.iddar.com
letraslatinas.venezuela@gmail.com
35, 67, 118

Juan Madriz
Edo Falcón, Venezuela
63, 117

Acknowledgments

This book would not have been possible without the designers whose works are featured in its pages. I am deeply grateful for their generosity and willingness to participate in the project. Thanks to Juan Carlos Darias who helped round up and pitch the project to Latin American designers and to Takako Terunuma from the Tokyo Type Directors Club for helping with connections in Japan. As always, I am fortunate to work with a great team at Rockport who make the writing and editorial process enjoyable and rewarding.

This book is dedicated to Howard, who was willing to stay in when work had to be done and to go exploring when I needed a breath of fresh air. I am eternally thankful for your patience and support.

About the Author

Aaris Sherin is an educator, writer, and designer. She is an associate professor of graphic design at St. John's University in Queens, New York. Sherin is a frequent lecturer and speaker at both national and international design conferences. Sherin is the author of *SustainAble: A Handbook of Materials and Applications for Graphic Designers and Their Clients* (Rockport Publishers, 2008), and coauthor of *Forms Folds and Sizes:* 2nd Edition (Rockport Publishers, 2009). As guest editor of *GroveArt* (Oxford University Press), Sherin supervised the addition of more than thirty entries on female designers as part of the 2006 Women in the Arts update. Her writing has been featured in publications such as *PRINT Magazine, STEP Inside Design, Form, Leonardo* (MIT Press), and *Design and Culture.* Sherin is founder of Fit to Thrive (fit-to-thrive.com) a consultancy company that addresses complex issues including the environment, creative thinking, and innovative problem solving that can occur across media and disciplines.